The
Colored Pencil
Artist's Handbook

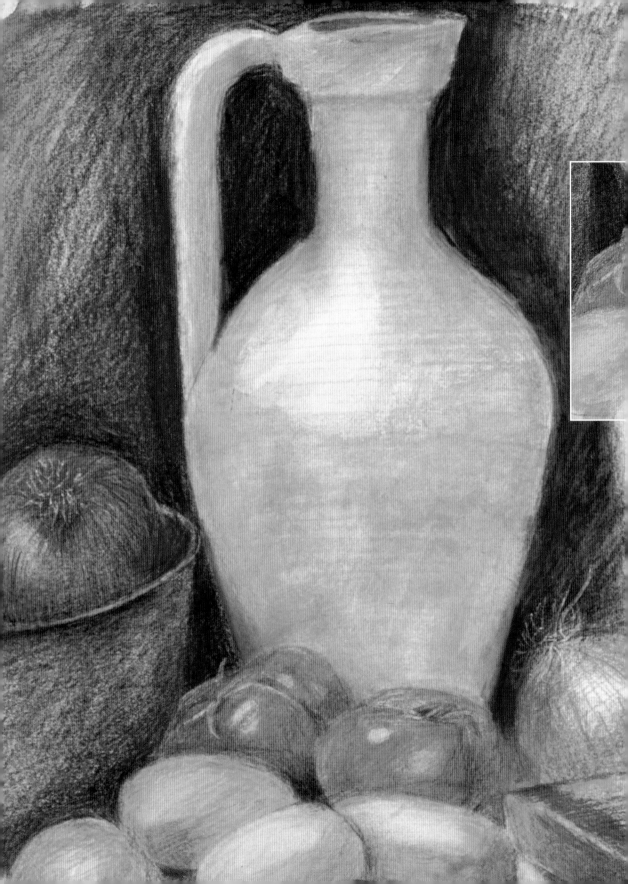

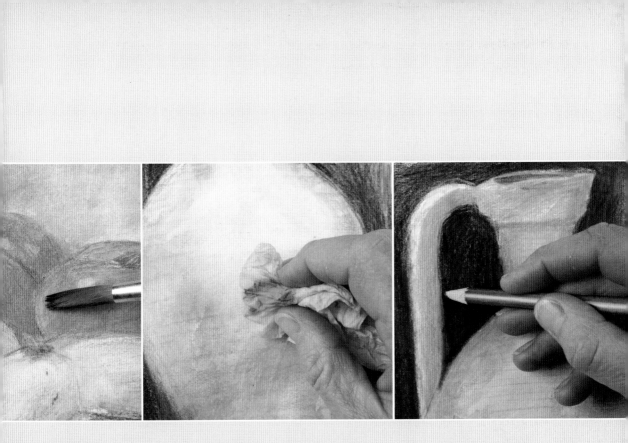

The
Colored Pencil
Artist's Handbook

Jane Strother

CHARTWELL
BOOKS

A QUARTO BOOK

Copyright © 2008 Quarto Inc.

This edition published in 2016 by
CHARTWELL BOOKS
an imprint of Book Sales
a division of Quarto Publishing Group
USA Inc.
142 West 36th Street, 4th Floor
New York, New York 10018
USA

Reprinted 2016

All rights reserved. No part of this
publication may be reproduced, stored
in a retrieval system, or transmitted in
any form or by any means, electronic,
mechanical, photocopying, recording,
or otherwise, without prior written
permission of the copyright holder.

ISBN: 978-0-7858-3383-3

Conceived, designed, and produced by
Quarto Publishing plc
The Old Brewery
6 Blundell Street
London N7 9BH

QUAR: CPSB

Project editor: Emma Poulter
Art editor: Julie Francis
Copy editor: Hazel Harrison
Proofreader: Ruth Patrick
Indexer: Dorothy Frame
Photographer: Martin Norris
Managing art editor: Anna Plucinska
Art director: Caroline Guest

Creative director: Moira Clinch
Publisher: Paul Carslake

Color separation by Modern Age Repro
House Ltd, Hong Kong.
Printed by Toppan Leefung Printing
Ltd, China.

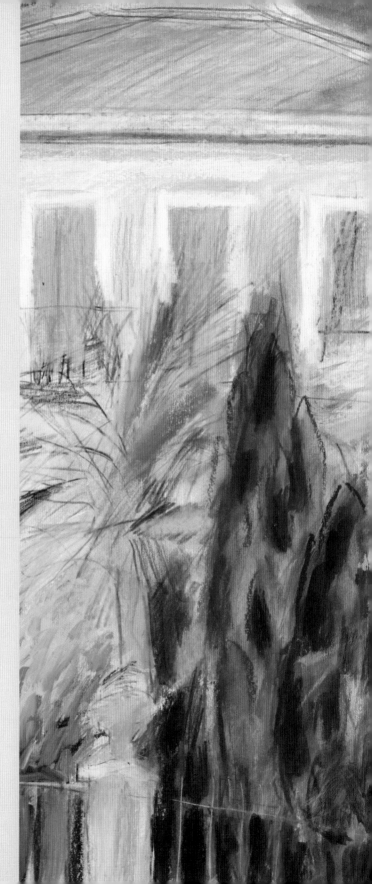

Contents

Introduction

The primary role of an artist is one of communication and interpretation; the medium and the skills you acquire in handling it are the means through which you express your ideas and pictorial interests. Interpretation is a personal matter, and cannot be taught, but practical skills can, and the aim of this book is to provide you with a repertoire that allows you to make the most of your colored pencils. But there are many different ways to draw and paint, and although practicing methods and techniques can be stimulating and fulfilling, openness to experimentation and exploring options is often the best way to success. You as the artist have an influential role to play, and I hope that you will see this book as a stepping stone toward developing your own way of working.

Colored pencils are an excellent medium for the newcomer to drawing and painting, and will be familiar to many through childhood "coloring-in" exercises, but they can also produce highly sophisticated results, and the pencils used by artists today are a world away from the cheap and cheerful

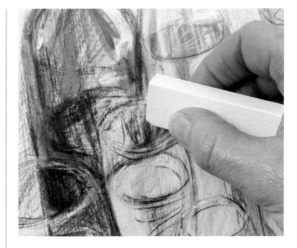

Techniques *Step-by-step demonstrations take you through the all-important techniques.*

crayons of the schoolroom. Highly versatile, they can be used as a drawing or a painting medium, either on their own or in conjunction with other media.

The Colored Pencil Artist's Drawing Bible is divided into several sections, starting with the basic tools and materials required, following on to a chapter on how to use them, each technique illustrated with clear step-by-step demonstrations by professional artists. Here you will find advice on basic drawing skills such as hatching, shading, or blending as well as those with a more specialized use, such as burnishing or impressing. "All about color" offers insights into color

Pencil ranges
Types of colored pencils and their use with a range of other media are discussed.

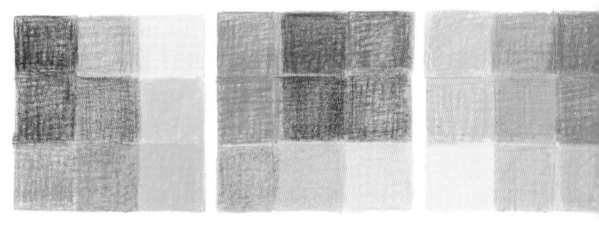

Color *All aspects of color theory are clearly explained.*

relationships, and how you can use these to give your work additional impact. You will also learn how to mix colors, achieving many different hues with quite a small basic palette. "Planning and Procedures" will help you decide how to compose your pictures, how to choose the best viewpoint, and how to get the most out of your sketchbook studies.

The latter part of the book contains several full-scale demonstrations, allowing you to "look over the artist's shoulder" to see how each one goes about their personal style of picturemaking and builds up their effects. This is followed by a gallery of finished works by a variety of artists, which bears testimony to the versatility of the medium and hopefully will give you ideas as to how to develop and enrich your own drawing style. Finally, the "Subjects" section provides a wealth of possible drawing subjects with a selection of photographs divided into themes, along with advice on how you might translate them into colored-pencil drawings.

All in all, **The Colored Pencil Artist's Drawing Bible** is a must have for anyone interested in this medium, whether a beginner or a more experienced artist looking for new approaches.

CHAPTER 1

Tools and Materials

Types of colored pencil

The main difference between types of colored pencil is whether or not they are water-soluble. The latter can be used wet or dry, providing a high degree of textural variation. Both these and any of the softer, waxier pencils create subtle shading effects and color gradations.

Line work, hatching, and shading with any degree of intricacy requires a finer pencil, which retains a sharp point for longer, even if the preliminary work is done with a water-soluble one. In fact, some of these pencils perform extremely well on a surface previously worked with water-soluble pencil—wet or dry.

Working with a combination of both types of pencil provides an opportunity for a greater range of marks and layering of color, although the variations may be slight.

Watercolor effects
Water-soluble pencils, such as those shown on the right, are easy and convenient to use. Used wet or dry, the pencils can be used to create a variety of effects from bold, vibrant colors to delicate watercolor washes.

Color ranges *There are a number of color ranges available, and the pencils vary in character from chalky and opaque or soft and waxy, to hard and translucent. These variations are caused by the different proportions of binder—the substance that holds the pigment together.*

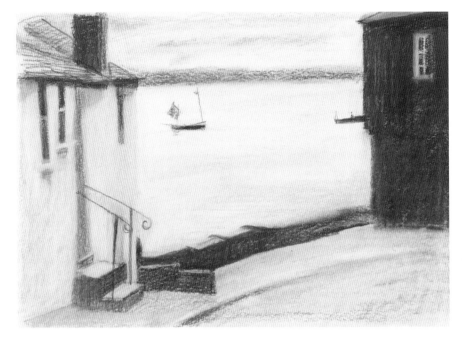

Specific sets *Sets of pencils can vary from as few as 12, to as many as 120. A good choice, initially, could be the special landscape and portrait sets, which include a balanced range of muted "natural" colors in warm and cool hues, and light and dark tones. Glimpse of the Harbor (shown above) uses a fairly neutral "drawing set" (shown right), specifically designed for both landscape and portrait work. The initial shading shows a grainy texture on cartridge paper, subsequent work binds the layers together producing the soft, creamy blend seen in the foreground, or the dark blue-brown of the house on the right.*

ARTIST'S TIP

Pencils need to be sharpened regularly, so include a craft knife and a pencil sharpener in your tool kit. Generally the knife is the most useful as it stays sharp for far longer. The blade is made in sections, and when it becomes blunt, you simply remove the top section with a pair of pliers. Reserve the pencil sharpener for reclaiming points rather than for shaving off the wood.

Paper types

The paper you choose will influence your drawing style, so it is important to go for something sympathetic to the marks you intend to make, or allow the paper itself to dictate a particular quality in your drawing.

Drawing (cartridge) paper is a good all rounder. It is relatively smooth, but has a slight tooth that gives a grainy quality to lighter strokes. With increased pressure, the grain will fill in, and either become less obtrusive or totally lose its effect. For fine or detailed work, a smooth surface is essential, but not too smooth. It is impossible to build up any density without some tooth to hold the pigment; pencils will skid on a shiny, slippery surface. As a rule, the more heavily textured the paper grain, the longer it stays open and allows the build-up of pigment.

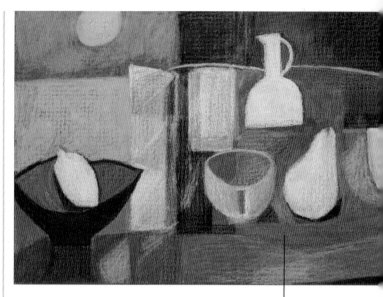

Pastel paper The pronounced grain of pastel paper is evident in Moonlit Table. The regular patterned appearance is reflected in the flat, blocked-in shapes; a more detailed, fluid image would be less suitable for this paper.

Drawing papers From left to right: Absorbent heavyweights in green, cream, and two tones of buff (*1–4*); lightweight, mold-made Ingres paper (*5–6*); medium-weight, hot pressed papers in cream, green, and gray (*7-9*); heavy, hot-pressed paper (*10*); rough white paper (*11*); rough paper with a pronounced tooth (*12*); handmade heavyweight paper (*13*); small-sized sketchbook (*14*).

1

2

3

4

5

6

7

8

9

10

11

12

13

14

Drawing paper

This has a relatively smooth surface, but the texture can vary. The example shown here has a relatively defined grain; texture is evident even when heavy pressure is used. On a lighter-grained paper, texture will be less evident as the grain fills with pigment.

Watercolor paper

Standard watercolor paper, known as cold-pressed, can be too heavily textured for colored pencils—shading over the surface will leave the "dips and troughs" free of pigment. The more suitable types have texture but little obvious grain, and will allow a considerable build-up of pigment when shaded.

Colored pastel paper

A relatively pronounced texture is needed to grip the loose, powdery pigment. This paper would not be suitable for detailed colored-pencil work, but works well for some styles, for example, those used in *Moonlit Table* on page 12.

Shiny paper

If the paper is too smooth, the pigment simply sits on the surface. If you try to deepen a pale color, you will see an immediate waxy build-up wherever heavy pressure has been used, reminiscent of children's wax crayons.

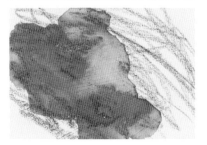

Paper painted with acrylic primer

The brushmarks used to apply the primer create a coarse texture that tends to break up pencil strokes. Applications of water-soluble pencils dissolved in water can give very rich results; the surface holds the pigment but doesn't absorb it, and the bright white quality enhances the translucency.

Sketchbooks

Sketchbooks or pads come in all shapes and sizes; softback, hardback, landscape or portrait format, spiral bound or with a sewn binding. The quality of the paper will vary so check details on the label giving weight and texture. What you buy depends on your purpose; for quick sketches in the field, something smallish with a hard back would be a good choice, and for exploratory studio work a larger one, with easily removed sheets.

Hard-backed
Many people are attracted to these seductive hard-backed, blank books just asking to be filled with your thoughts and ideas, drawings, and writings.

Sewn-in bindings *Sewn-bound sketchbooks are made in many shapes and sizes, and usually have either printed marbled covers or black canvas ones. They are more expensive than spiral bound pads, but are substantial enough to last for a long time.*

Spiral-bound pads *These are easy to use, as the paper lies flat. Choose one with a heavy backing that acts as a support to lean on. The binding can be an obstacle, however, especially if you want to work on a double-page spread, and a flimsy front cover won't protect it from becoming dog-eared in your backpack.*

ARTIST'S TIP

If out and about, keep a small sketchbook to hand—in the event that inspiration strikes, it's good to be prepared. Remember to keep a bulldog clip handy too—you'll need to secure those pages on a windy day!

Different sizes

Whether sewn-in or spiral-bound sketchbooks are your thing, keep several sizes and shapes for specific needs or to record separate trips and projects. Sewn binding has the added advantage of allowing a drawing to cover a double page spread, an option worth considering.

Formats *Landscape and portrait format hardback sketchbooks with sewn binding.*

Stretching paper

Paper is made in different weights, expressed as lbs per ream or grams per square meter (gsm). If water is to be applied to the surface, or a wet pencil is used, all but the heaviest need to be stretched to avoid buckling. There are two ways of doing this, and artists have their own personal preferences. You can either soak the paper on both sides in a bath, lift it out by a corner, and shake off the excess before placing it on a board and sticking paper tape around the edges, or you can wet one side only. Some artists complain that the surface is stirred up when soaked; to others this can be an expedient. For drawing and mixed media work, soaking the whole sheet when stretching can be an advantage. It changes the nature of the surface and facilitates a superb line quality.

Once your paper is stretched and dry, you can prime it with primer (see page 56) or apply any other sort of ground or color you wish (see page 45 for more about coloring paper).

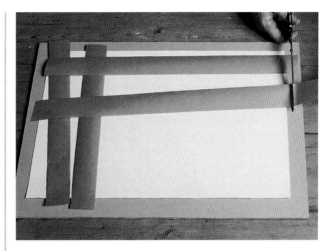

1 Prepare four strips of adhesive-paper tape, approximately 2 inches (50 mm) larger than the paper.

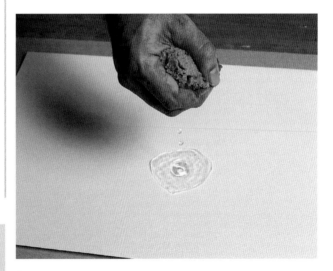

2 Lay the sheet of paper centrally on the wooden board and wet it thoroughly, squeezing the water from the sponge. Alternately, the paper can be wetted by holding it under a running faucet, or by dipping it into a water-filled tray or sink.

ARTIST'S TIP

Stretching paper in a sketchbook is obviously not possible, but in the case of a sewn-binding sketchbook you can help to prevent the paper buckling by applying a wash to pages, allowing them to dry thoroughly, and then closing the book and weighting it overnight.

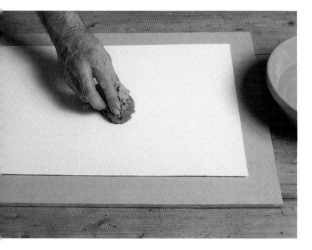

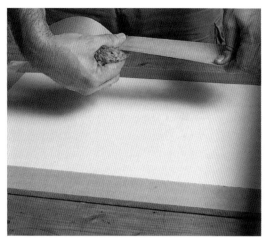

3 Wipe away any excess water with the sponge, taking care not to distress the paper surface.

4 Beginning on the longest side of the paper, wet a length of tape using the sponge, and lay it down along the edge. Ensure that about one-third of the tape surface is covering the paper, with the rest on the board.

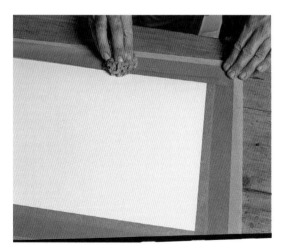

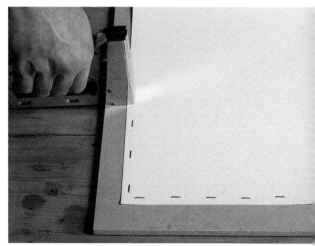

5 Smooth the tape down with the sponge. Apply the tape in the same way along the opposite edge and then along the other two edges. Place the board and paper aside to dry for a few hours, or use a hairdryer to speed up the drying process, but keep the dryer moving so the paper dries evenly, and do not hold it too close to the paper's surface.

6 Staples can be used to secure medium- and heavyweight papers. Wet the tape and position it on the board, as above. Secure the edges by placing staples at regular intervals, working quickly before the paper buckles.

Essential tools

The beauty of colored pencils as a medium is that few additional tools are needed for studio work, and even less for outdoor sketching. A list of items for outdoor work is given on page 87. For studio work, you will usually require a larger range of pencils than for sketches, though don't go overboard and buy a vast range (see the suggestions for a basic palette opposite). If you are interested in mixed-media work, you may wish to have other media such as inks and watercolors to hand, and you may also want to experiment with different kinds of paper.

If you like to work on a large scale, you will need a drawing board, which can be just a piece of furniture board cut to size. An easel is not essential, but you may find that it encourages you to work more freely. You may also need some form of lighting if your work space is not adequately lit, or if you are working outside the daylight hours. There are many inexpensive adjustable table lamps available, and you can also buy special daylight bulbs in most art stores.

Erasers
Erasers can be used as a drawing tool, as well as to make corrections. The type of eraser you choose depends on your paper: a kneadable eraser for smooth papers and a firmer plastic eraser for more textured types.

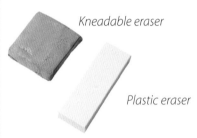

Kneadable eraser

Plastic eraser

Drawing board
The working surface you choose depends very much on how large you want to work, but most artists use a drawing board of some kind, whether a ready-made one or a sheet of medium-density fiberboard (MDF).

Anglepoise lamp
If you are not blessed with good natural light, or want to work in the evening, you will need a good lamp. Angelpoise lamps are ideal, because they are adjustable and can be changed to different heights and angles.

Basic palette

A suggested basic palette for colored-pencil work would generally include two or three versions (or hues) of each of the primary colors—red, yellow, and blue. Remember to include some darks and lights to add tonal value to your work.

There are several variations you may want to include in your palette: lemon, cadmium, and ochre as variants of yellow; ultramarine, turquoise, cerulean, and indigo as a choice of blues; and scarlet or vermilion, and magenta or crimson, for differing shades of red. An olive green, burnt sienna, and a pastel pink are also useful additions. It is also a good idea to include some neutral colors such as browns and grays.

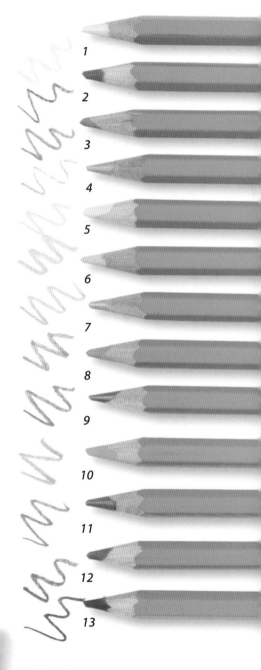

On the move
The suggested basic palette for taking on trips out, from top to bottom: cool pink (1), magenta (2), vermillion (3), French gray (4), lemon yellow (5), cadmium yellow (6), yellow ochre (7), raw sienna (8), olive green (9), light turquoise (10), spectrum blue (11) ultramarine (12), and indigo (13).

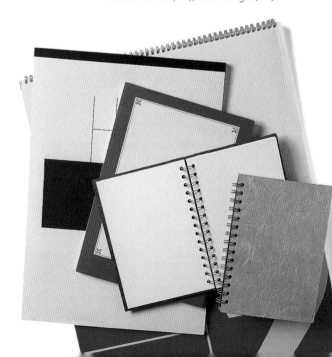

Sketchbooks
You should stock up on a range of sketchbooks of different sizes and formats.

CHAPTER 2

Techniques

Handling pencils

There is no right or wrong way to hold a colored pencil; any grip that is comfortable and gives you control of the pencil movement is right for you. However, you may vary your handgrip depending on the nature of the paper, the area to cover, and the direction of the marks you intend to make, and thus the effects you obtain will vary subtly as you alter your grip and pressure.

The conventional grip in which the shaft of the pencil rests in the curve of the thumb and first two fingers gives tight control and enables you to make very delicate marks, firm lines, and careful shading by small movements of the fingers, wrist, or hand.

For more open, scribbled, or hatched textures use more sweeping movements of your hand and arm. Alternately, grip the pencil with your hand either over or under the shaft, which encourages free, gestural movements. Shading with the underhand grip can be light and quick, and with the overhand one, heavy and vigorous—especially if you stand at an easel or at a tilted board.

Using an easel

Working at a sturdy easel encourages full use of the arm as well as the wrist and so facilitates sweeping movements, more flowing marks, and perhaps heavier pressure. Perspective is often easier to judge, particularly vertical and horizontal structures as you are working on the same plane.

The "writing" grip
Use this conventional grip for maximum control where extreme precision is required.

The underhand grip
This grip will facilitate free movement of the wrist, and is ideal for open shading.

WORKING POSITION

Your choice of working position depends greatly on how large you want to work. If you are not using an easel, then a drawing board is a good idea. Propped up on some wooden blocks, or against a table as shown here, an angled board is ideal for drawing, and can help with your posture too. Always ensure you are sitting comfortably—an adjustable chair is a good idea, especially for those with back problems. But regardless of the type of chair you use, try to stand up regularly and avoid spending long periods of time hunched over your work.

The overhand grip
Heavier, more gestural marks can be made with this grip.

Wrist movement
Curves and ellipses are more easily created if your wrist is allowed to move freely. Here the wrist has twisted from a position in line with the hand to one almost at right angles.

Mark-making: Dry pencils

Marks are the means through which you record and translate your visual experiences, so before launching into drawing an actual subject from life or memory, gain familiarity with your materials. You could divide your page with a grid similar to the one shown here, or allow yourself to freely roam over the page. Become absorbed in the lines, dots, shading, and the relationships between colors you produce—and the differences between brands, if you are using more than one.

1 Loose, scribbled marks and a medium pressure on watercolor paper.

2 Loose, shaded marks with a slightly heavier pressure on watercolor paper.

3 Sharp point and medium pressure on smooth drawing paper.

4 Sharp point and medium pressure on drawing paper stained with thin oil pastel.

5 Dense crosshatching in one color on smooth drawing paper.

6 Dense, scribbled marks in several colors, overlaid and blended. This decreases their intensity and enhances the flashes of orange.

7 Firm, even pressure on smooth drawing paper.

8 The grain of the paper filled with layers of the same blue.

9 Fine scratched marks add further subtlety to heavy shading on textured paper.

10 Firm pressure on heavy, smooth drawing paper.

11 Short, energetic hatched red marks on a complementary lime green.

12 Loose shading in harmonious pinks and reds on textured paper.

13 Vibrant dark tones created by dense layering of blue, red, and yellow.

14 Light shading in blue and yellow to produce green.

15 Close, linear hatched marks in different colors to produce a blended effect.

16 Color densely shaded over impressed marks (see page 36) on smooth drawing paper.

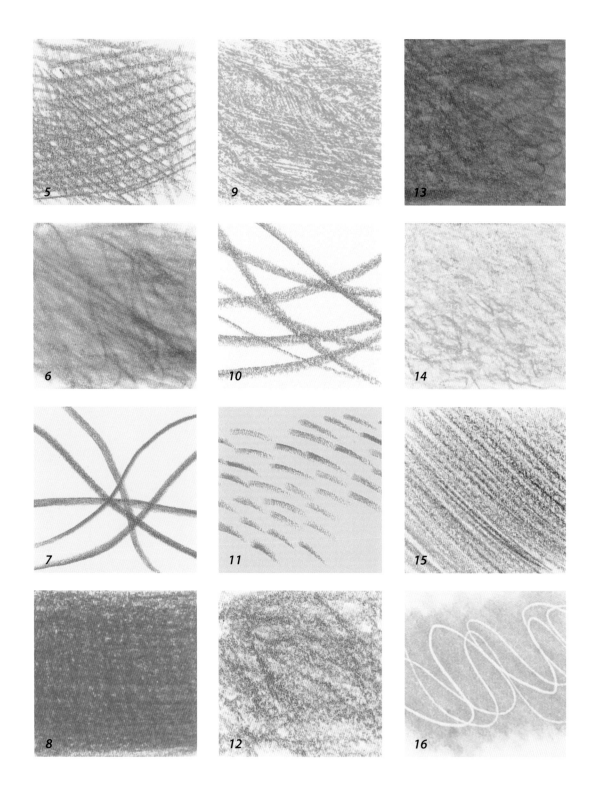

Hatching

Hatching and crosshatching are blending techniques, traditionally used to build up areas of tone in monochrome drawings using a linear medium, such as pen and ink drawing or engraving. In colored pencil work, these methods are an effective way to mix colors or to modify them.

Hatched lines are roughly parallel and can take any direction. Heavy lines, closely spaced, give a fairly solid area of tone or color, appearing more dense than widely spaced, light lines. Crosshatching is simply two or more sets of lines hatched one over another in different directions. An area of dense crosshatching would read, from a distance, as a continuous tone or color. The direction of the lines can be carefully manipulated to represent form and volume or loosely massed to give a lively surface or sense of movement.

Working in line only does not have to be restrictive. It can be a very free and unencumbered way of drawing from life, as there is plenty of scope for redrawing or adjusting marks by overlaying new ones, gradually building up a more complex finished piece.

Regular hatching

Hatched lines can be of equal weight and spacing or may vary with gradual alteration in thickness and spacing.

Evenly spaced hatched lines of equal weight.

Lines of varying thickness, spacing, and weight.

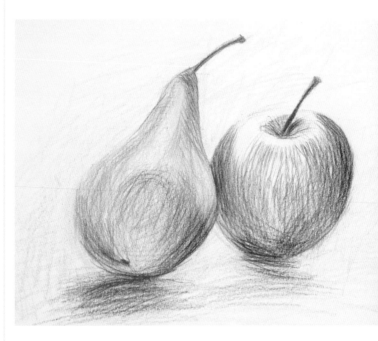

Free hatching *Worrying about the precise direction and spacing of hatching and crosshatching can sacrifice the sense of life and energy in a drawing, so free yourself with some quick studies such as the apple and pear shown here. The pencils have been allowed to move easily following the form of the fruit, and the directional marks have been extended into the background for added dynamism.*

Crosshatching

The denser texture of the closely crossed lines allow you to develop deeper and livelier color as the white of the paper is gradually eliminated.

Hatched and crosshatched lines can be used to effectively blend two or more colors.

This loosely hatched and crosshatched sketch uses change in pressure to alter the tonal balance.

Hatched lines can be loosely massed to give a lively surface or a sense of movement.

Blending

Blending one color into another is generally achieved by shading—using the side of the pencil and moving it back and forth across the paper. Using the side of the pencil leaves a softer, more open mark than the point, especially on grainy paper, which can be gradually blended into an adjoining color by subtly overlapping the edges of the two colors so that neither is dominant and there is no discernible join. This is known as feathering.

Blending two colors

An effective blend is made by loosely shading over an existing color of a similar hue or tone; the two mingle and appear as a blend although there are two distinct layers. This is more pronounced when shading on previously colored paper with a grain, as the pigment sits on the surface and leaves the "dips" in the lower sheet free—the eye will blend two colors used in this way, achieving a lively surface quality.

Blending with an even light pressure and no linear bias.

Blending with heavy pressure for increased intensity of color and tone with emphasis in the direction of shading.

Feathering using light and moderate pressure in one direction to blend two colors.

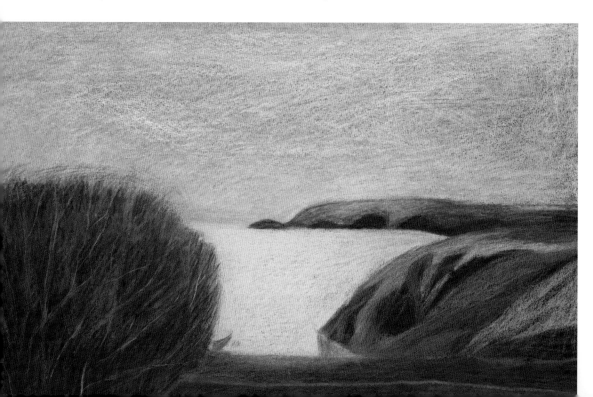

Blending by unifying
The effect of sunlight in
Formal Garden shown
left, is emphasized by
shading with yellow
over large patches
of previously worked
color. This helps to
pull the composition
together, brightening
even the shaded areas.
The watercolor paper
used for the drawing
is soft, with no obvious
grain, which aids
the merging of the
pencil strokes, seen
particularly in the
light and shade of
the hedge in the
background.

◀ ***Working on dark paper***
The seascape shown opposite,
Dinas Head, has been worked on
black paper, with yellows and pinks
blended by means of shading and
heavy pressure to cover the paper.
The colors appear light on the dark
ground, evoking a quality of light
characteristic of this coastal area.

OPEN SHADING

This is the result of loose movement of the wrist, which
allows the whole hand rather than just the fingers to
manipulate the pencil and to produce free, descriptive
marks over the whole picture surface. This method
might be used to build up basic shapes in the first draft
of a picture subsequently to be worked up in depth,
and is a good way to eliminate unwanted tightness
at the beginning of a project.

Blending with solvents

The marks made with some types of colored pencil can be blended with solvents—water, turpentine, or the spirit-based medium in a colorless marker blender. Only pencils formulated to be water-soluble will react with water. Spirit solvents may dissolve the colors of pencils intended to be used dry—this has to be a matter of experiment, as it depends on the proportions of the pigment and binding materials in the pencil lead, and the effects are not wholly predictable.

There are two methods that enable you to take advantage of the more fluid textures produced by solvent techniques. You can either dip the tip of the pencil into the solvent, so that the color becomes softened and spreads as you lay it down; or you can shade or hatch with a dry pencil tip and work into the color area with the solvent using a brush, paper stump (torchon), or cotton bud—or with a marker blender, which is simply a marker pen that contains a colorless solvent. You can combine the effects of wet and dry color by allowing the dampened marks to dry, then reworking the area with the pencil.

To avoid distortion that may occur through the paper buckling when it is wetted by the solvent, stretch the paper beforehand, or work on a pre-stretched paper block or board.

ARTIST'S TIP

Unless you use very thin paper, no stretching is required when working with solvents, as they don't buckle the paper like water does. But bear in mind that spirit or turpentine can stain colored paper, and if using a marker blender, the tip needs to be kept clean or it may become contaminated and dirty future blending.

Using spirit solvent

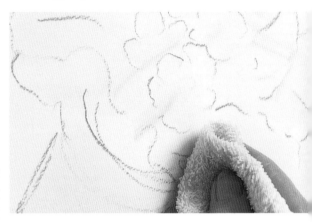

1 The shapes of the flowers are rapidly sketched with a soft, waxy pencil line. A rag dampened with turpentine is used to spread the color delicately, indicating the areas of darkest shading.

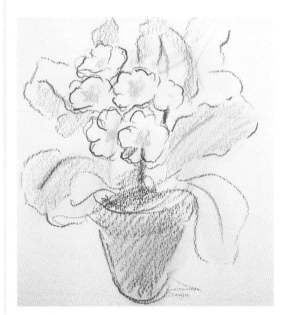

2 The line drawing is strengthened and some broad color areas blocked in with light shading. Notice the heavy grain of the watercolor paper—when applying solvent, you need to use good-quality paper to avoid buckling or tearing.

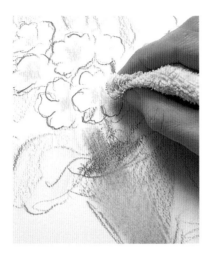

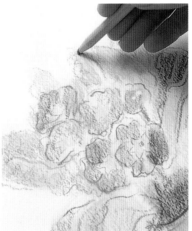

4 To develop the intensity of color, pencils are used once more to shade in the solid shapes. The moisture from the underlayers makes the pencil marks smoother and more vibrant.

3 A second stage of rubbing with turpentine softens the color and spreads it into the paper grain. The pencil marks are just moistened, not flooded with the solvent.

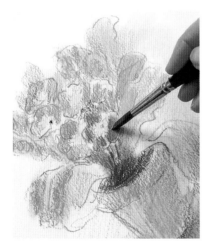

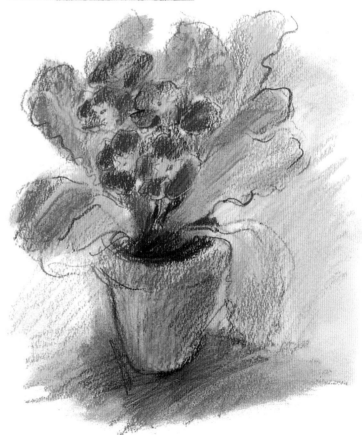

5 Applying solvent with a brush makes the color dissolve and spread more like paint. It is possible to do this selectively, to build up a contrast of different textures.

6 In the finished vignette, the brushed color comes up very fresh and intense, contrasting nicely with the more open surface qualities of the pencil shading and line work.

Blending water-soluble pencils

Water-soluble pencils are wonderfully versatile, as they can be used both wet and dry, or a combination of the two, in any one drawing. Apply water with a brush, rag, or fine mist spray after the pencil is applied, and some of the pigment will dissolve, leaving soft and hard edges. Adding more water may even remove the drawing element completely to produce a watercolor wash effect. You can wet the paper before drawing, or dip the tip of the pencil in clean water to give a soft line.

It's advisable to stretch your paper (see page 16) unless it is the heaviest watercolor paper, but if you plan to use a limited amount of water, just enough to dampen the paper, try attaching it to a board with masking tape on all sides. This is a good method for instant sketches.

ARTIST'S TIP

There are many types of brushes you can use. As you become more experienced, you will begin to learn which type of brush works best for you. Remember: a good brush should have a certain resilience. You can test the spring of a brush by wetting it into a point and dragging it lightly over your thumbnail. It should not droop but spring back.

Blending more than one color

Lay down two dry colors one on top of the other and wash with water—once you have blended them there is little significant difference as to the order in which they are laid. Differences are more discernable when dry pencils are laid over each other, as you will see below.

The crimson (top right) slightly dominates the viridian when laid on top, although these two hues are similar in tone, as is evident when the colors are laid the other way round (top left). There is little difference once washed over.

Yellow over purple (top left) looks quite different to purple over yellow (top right) because of the contrast in tonal value between the two. However, the differences are not so evident once they are washed with water (see bottom row).

Red over lime green (top left) and lime green over red (top right) are tonally very similar, but there is a slight change in hue. Again, the differences in hue, and the order in which they are laid, are less apparent once washed with water.

Blending with water

Blending with water, using a brush, sponge, or rag, allows subtle mixtures and varied line quality to be achieved.

1 A swatch is made using a dry pencil.

2 Water is added with a brush and the color is blended more thoroughly, loosing most of the pencil marks.

Dipping the pencil in water first produces different marks. Where the pigment is wet, it makes a deeper and stronger mark that tails off as it dries.

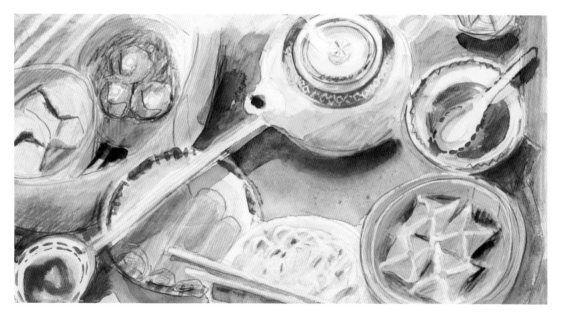

Watercolor effects

This drawing, Chinese Dishes, *was begun with a rough sketch blocked in with shading, much of which was then dissolved using water and a brush to create a fluid watercolor painting. It was then reworked with drawn lines and some loose shading to emphasize shape and form, and the process was then repeated. The stages are integrated so that it is not always possible for the viewer to identify the order in which they were made.*

Mark-making: Water-soluble pencils

Using water-soluble pencils will give a different appearance to the marks you make. Depending on your approach, your finished work might resemble a watercolor painting rather than a drawing, with few visible pencil marks, or alternatively, you might choose to employ the contrast between water-blended areas and pencil texture. Use the examples shown here as a starting point for your own experiments until you feel you can use the medium with confidence to describe and interpret your subject.

1 Wet, red pencil with heavy pressure over dried water-blended color.

2 Red acrylic ground allowed to dry and overlaid with blue pencil blended with water. The red and the blue will not mix.

3 Yellow overlaid with green and softened with a wet brush.

4 Color spread with water to produce a thinned and lightened blue.

5 Red-stained paper with water-blended blue laid on top and then scratched with a craft knife to reveal the underlying color.

6 Scribbled wet pencil marks lightly meshed together.

7 Scribbled, soft marks made with a pencil dipped in water.

8 Two colors begin to blend with solvent in the form of a marker pen.

9 Impressed marks (see page 36) on red-stained paper with shaded overlay in green.

10 Scribbled marks blended with water and allowed to "pool" as in watercolor.

11 Blue blended with red on grainy paper. The marks have been softened but still remain visible.

12 Dry pencil over a previous layer of water-blended blue.

13 Marks on wet paper, colored with a pencil wash.

14 Marks on dry paper with water brushed over the surface afterward.

15 Texture created by layering wet and dry pencil marks.

16 Wet pencil loosely scribbled over commercially made colored paper.

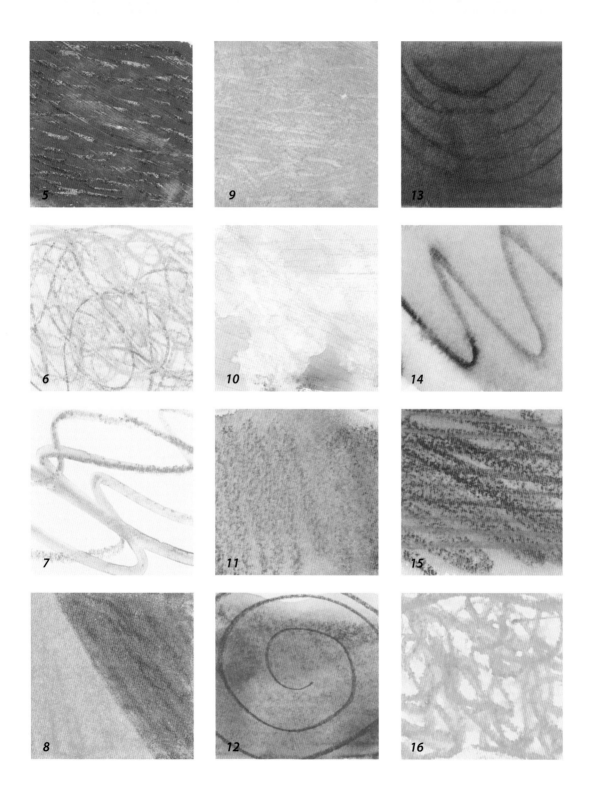

Impressing

This is a way of producing clean "negative" lines in a drawing by indenting the paper. When worked on white paper, it is also known as "white line drawing." Lay a sheet of good-quality drawing paper or a smooth watercolor paper on a pad made from a few sheets of newspaper to provide the necessary yielding surface, and use an implement such as a "dead" ballpoint pen or, a knitting needle or the end of a paintbrush handle to impress lines. Subsequent gentle shading will glide over the impressed mark, revealing the color of the paper. For a varying effect, use a sharpened colored pencil to make the lines, so the impressed line will be of that color rather than that of the paper.

Using tracing paper

Impressing can be done freehand, but if the drawing is complex, you can make it first on tracing paper, laying this over a clean sheet of drawing paper and retracing the outlines firmly with a pencil point. Impressing can be used to create specific decorative effects such as the patterns in a fine lace tablecloth, the delicate tracery of leaf veins, or simply as a negative outline in white or the chosen paper color.

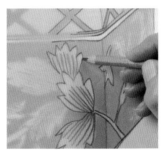

1 Place a sheet of tracing paper over your chosen design and make a pencil tracing of the whole image.

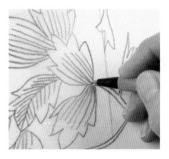

2 Remove the tracing paper from the image, lay it over your drawing paper and redraw the lines to be impressed using a ballpoint pen or pointed implement.

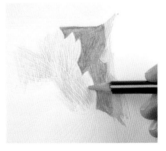

3 Remove the tracing paper. Using the side of the pencil, shade over the impressed surface to reveal white lines.

4 The shading can be taken a stage further to include more than one color, but make sure that the impressed lines are kept free of color.

ARTIST'S TIP

It is useful to keep one or two alternate impressing "tools" for different thicknesses of line; a compass point will give a finer negative line than a paint-brush handle.

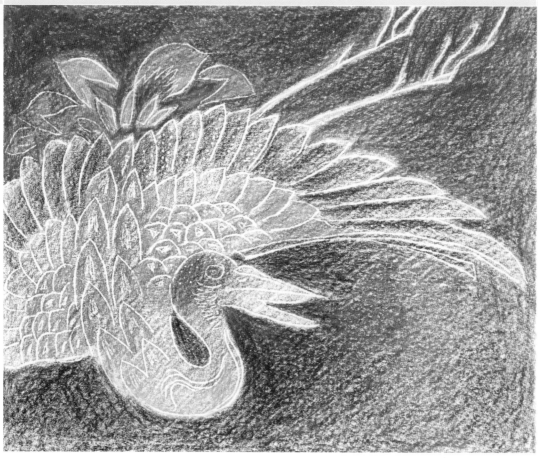

▲ White line drawing

This crane design is taken from a nineteenth-century Japanese fabric. The white lines are made by tracing the image with a ballpoint pen, impressing a "blind" line onto smooth white drawing paper.

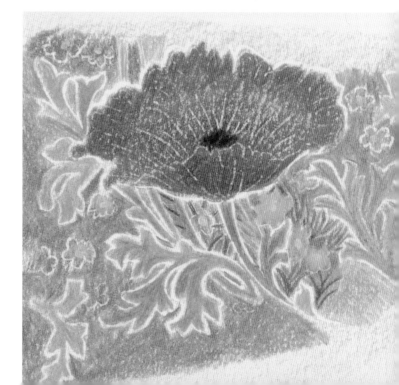

▶ Negative outline

The poppy design uses an impressed white line as an outline, shaded lightly all over in pink before the green was added. The poppy head was shaded again in red before further impressing to give the fine, broken lines on the petals.

Sgraffito

Sgraffito is the technique in which an underlying layer is revealed by scratching or scraping the top one away. It works particularly well when the media is soft and easily removed, as with oil paint or oil pastel. Colored pencils tend to mesh together when overlaid and impregnate the surface of the paper rather than sit on the top, so care should be taken to avoid damaging it. However, sgraffito is reasonably successful when the pigment is compacted and on smooth or primed paper. Use the point for fine lines or scrape lightly with the side of the blade for broken areas.

Try representing the flicker of light penetrating dark foliage, the sky through tangled branches, a complex textured surface, or a distinctive linear structure, such as basket weave, waving corn, or the fragile veins of a leaf skeleton.

Scraping out

Removing color with a knife by scraping with the edge of the blade rather than the point, can be used to clear unwanted pigment build-up in order to rework or to create striking "negative" line drawing.

1 Use a colored pencil to build up an area of compacted color.

2 Here a second hue is added to deepen the color and to increase its density.

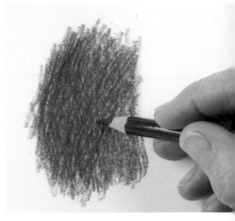

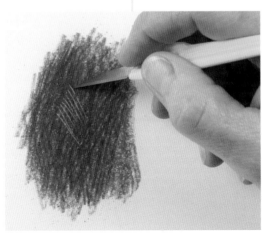

3 Use a craft knife to carefully scrape away fine lines or patches of color, so the white of the paper or the pigment underneath is revealed. Use the flat part of the blade rather than digging into the paper with the point.

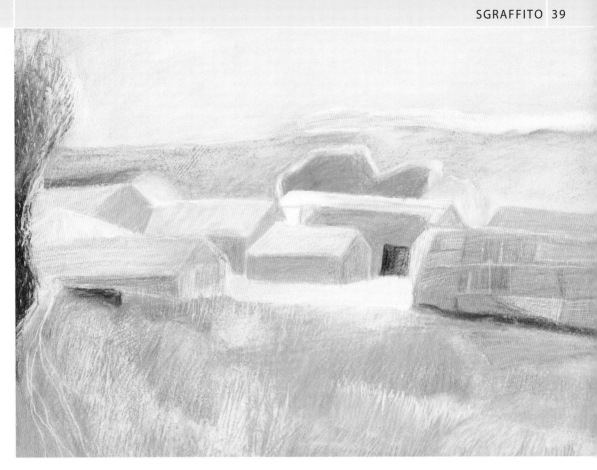

▾ Fine lines

Here fine lines are scratched into compacted pigment to emulate delicate leaf veins. The effect is reinforced with further gentle shading over the scratch marks; anything too heavy and they would fill in.

▴ Revealing colors

Merriscourt Farm—High Summer has been worked on primed paper, with sgraffito used to take out some of the dark tree mass on the extreme left to reveal the yellows and pinks beneath. Fine scratched hatching adds variety and detail to the straw bales and the barley field.

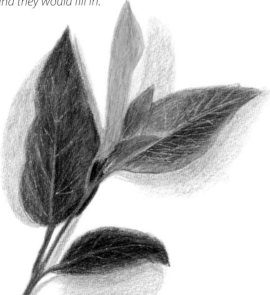

ARTIST'S TIP

For good results, prime the stretched paper (see page 16) with an acrylic or gesso primer or a layer of acrylic paint (see pages 56–57). This acts as a barrier between the pencil and the paper, preventing it from absorbing the pencil color. The top color can be scraped away with a craft knife to reveal white or colored marks.

Burnishing

Burnishing is used to give an overall finish to a drawing, to heighten selected areas, or to imitate shiny materials such as metal or glass. It is difficult to make radical changes to a burnished area once established, although it can be removed with water (if you are using water-soluble pencils) or broken up by scraping with a craft knife or even glasspaper.

To burnish with a colored pencil, apply a top layer to a previously worked area, using firm pressure so that the color is compacted and no grain is evident. This creates a smooth, blended surface, increasing brightness and reflectivity. The choice of hue adds a warm or cool bias to the subject, and also either heightens or subdues the color. Use a white or pale pencil for highlights and rejuvenate dark areas by burnishing with a relatively lighter or brighter color.

Effects of burnishing

Burnishing with a colored pencil creates a glazed surface effect. It compresses and polishes the first layer, pressing out the grain. It can give the impression of colors being more smoothly blended and increases the brightness and reflectivity of the surface. The color applied affects the original hue, as shown in the below examples, where the same red color has been subjected to several burnishing effects.

Dense shading in red pencil.

The same color burnished with blue-gray.

The same color burnished with light yellow.

Red is burnished with white.

Burnished with a torchon.

Highly compacted red, orange, and blue, partially burnished with white.

HOW TO MAKE A BURNISHING TOOL

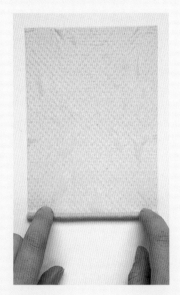

To make a burnishing tool, you need a toothpick and a small piece of paper towel. Soak the towel in water and then roll it around the stick, without letting the paper protrude too far beyond the points of the stick. The paper will shrink as it dries to form a tight covering, without the need for further adhesion. Your paper stump is then ready for use.

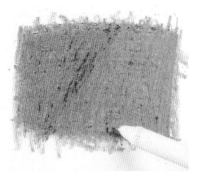

Burnishing using a tool
Half of the colored patch has been burnished by rubbing with a paper stump (torchon) to achieve a compacted and shiny effect.

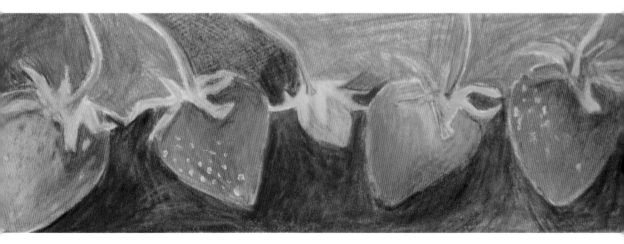

First of the season
Heavy pressure with a variety of red pencils was used for the four strawberries and then burnishing. From left to right, burnishing with white pencil, with yellow pencil, silver-gray pencil, with a paper stump (torchon), and with light yellow in the darkest areas of the background.

ARTIST'S TIP
Try burnishing with a rolled-paper stump (torchon) or a plastic eraser, to avoid the color changes caused by overlaying colors.

Working on colored paper

Colors and tones can only be judged in relation to each other, so the appearance of your pencil colors will inevitably be affected by the paper color. Red marks on a blue paper, for example, will look very different to the same marks on yellow paper. This applies even to "white" paper, which is always lighter in tonal value than the lightest pencil color, thus making the marks appear a little darker in contrast, especially if the white plays a dominant part in the work. Colors blended with water are brighter on white paper than they are on a colored or tinted ground.

You can buy various colored papers, but it can be more satisfactory to hand color them yourself. You can lay washes of watercolor or thin acrylic, but remember that the paper must be stretched in advance or it will buckle (see page 16). The choice of color depends very much on the subject and how you propose to treat it. You might choose a color that blends with the landscape you are working from, perhaps a pale cool blue for early morning light, or a contrasting color, such as red or yellow ochre for warm earth tones to enhance a predominately green landscape and bring it to life.

Colored-paper effects

A colored ground affects the appearance of the pencil color through contrast, enhancing or altering the different qualities of the color to a greater or lesser extent. Neutral tints such as beige, buff, or gray provide a mid-toned background and make good all-round choices; brightly colored paper will make a strong impact on the overall image, intensifying the hue and texture of the pencil marks, but be aware that a particularly vivid background may compete with the applied colors. The swatches on the opposite page show the varying effects a colored background can have on a color's appearance.

Neutral ground *On this pale gray ground the colors retain their identity, though the colors that are close in tone to the paper show up less clearly.*

Warm ground *The warm yellow ground enhances and lightens the more translucent yellow, pink, and cool gray.*

Cool ground *The cool blue ground shown here deepens and brightens the raw sienna, darkens the red and raw umber, and gives a slightly green tinge to the yellow.*

Dark ground *The colors all appear lighter on the darker, terracotta ground, but its intensity reduces the contrast, especially of the red, violet, and the raw umber.*

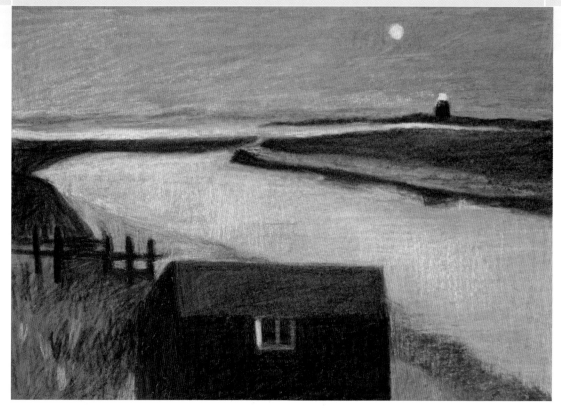

Inexpensive paper

Towards Reydon *is worked in dry pencil in cool blues and pinks on warm-toned brown sugar paper. This kind of paper can inhibit the build-up of layers, as the color quickly becomes compacted, and too much erasing will tear the surface. However, you may find that you can develop your work by changing the type of pencil used for the final layer—the new pencil will often adhere more successfully.*

Bright-colored ground *There is an almost luminous quality to this vignette in dry pencil on bright pink paper. Full use of complementaries or near-complementaries (see page 70) is seen in the use of the cool pink with the green of the beans and warm yellow lemon. The paler colors (pigment mixed with white) have a greater opacity than the others and so are less affected by the ground color, thus adding to the vibrancy.*

Coloring your own paper

Coloring paper yourself allows you to choose the exact hue you want and to modulate it to allow for a dense ground in one area and lighter in another. You can use oil pastel or acrylic paint as shown below, or even stain your paper with a used tea bag.

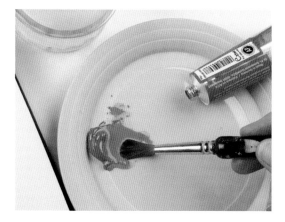

1 Squeeze a small amount of acrylic paint in your chosen color onto a plate or palette and mix it with a brush loaded with a generous amount of water. For a more fluid consistency, you may need to add more water to enable the paint to spread easily over the paper surface.

2 Using a brush, spread the paint over the paper, adding more water to the palette if necessary. Be sure to work quickly—If the paint starts to dry, hard edges will begin to occur.

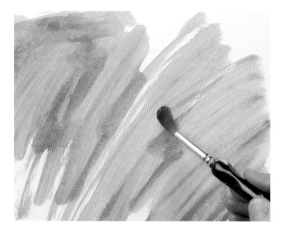

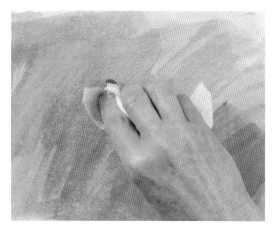

3 As you are painting, you will notice the brush marks are apparent. These can be either left as they are or smoothed out as shown in step 4 if they are too dominant.

4 While the paint is still wet, use a damp rag to spread the paint further to the edges of your paper and smooth out some of the brush marks. Once dry, your paper is ready to work on.

Transferring a sketch

With some types of colored pencil drawing it is important to have a clear and accurate guideline before you begin the color work. Corrections and erasures in the under-drawing can spoil the paper surface, so to avoid this, make a working drawing which can be transferred via tracing paper to the final drawing paper. Or, if you are working from a photograph or an existing drawing, you can enlarge or reduce it on a photocopier, and then trace the outlines. Alternately, you can scan the image into your computer and use the scanning software to make any necessary alterations before printing out, but this would limit you as to size.

Transfer paper

A quicker and cleaner method is to use transfer paper, which is similar to carbon paper but is made in a range of colors, and thus has the advantage of allowing you to choose a suitable color. Slip the transfer paper colored side down between the tracing and the drawing paper, and then draw over the outlines lightly.

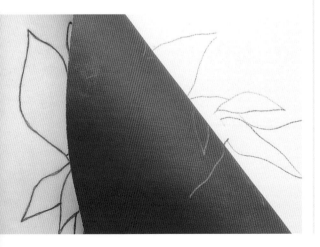

The tracing method

The conventional method of transferring a sketch simply involves using a piece of tracing paper and a colored pencil.

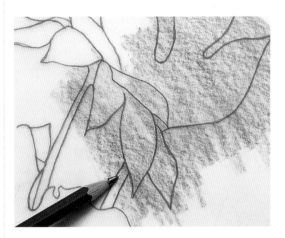

1 Draw the outlines on tracing paper, and then scribble on the back with a graphite pencil, coloured pencil, soft pastel, or chalk

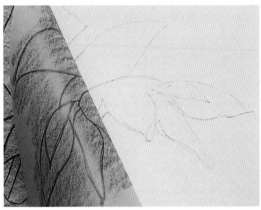

2 Place the tracing paper onto the drawing paper and go over the outlines again with a ball point pen or sharp pencil to transfer the image.

Resizing your image

If you don't have access to a photocopier to enlarge or reduce an image, you can do it by hand, as shown below. This is a slow method, but it is good practice, helping to sharpen your observation and drawing skills. All of these methods, however, are essentially devices for copying. Practice enlarging or reducing by eye to be sure of retaining the vitality of your work.

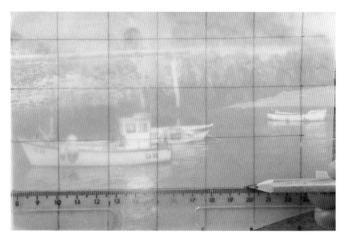

1 Draw a grid directly onto the surface of the image or onto a sheet of tracing paper or thin acetate laid over it. Use marker pen if using acetate.

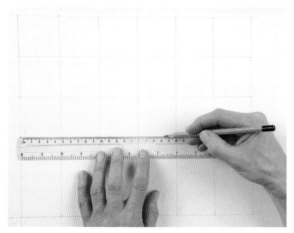

2 Draw a larger grid with the same number of squares but to the same scale as on your drawing paper.

3 Copy the contents of each square on to the equivalent square on the drawing paper. Plot the main points where shapes or edges cross over the perimeter of each square into the next one, carefully, before developing the detail.

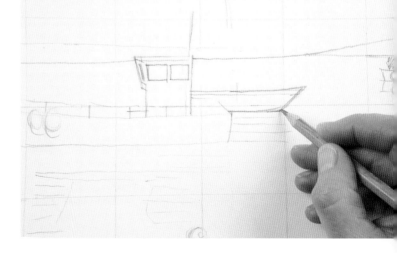

Masking

A mask is anything that protects the surface of your drawing and prevents color from being applied to a specific area. The simplest form of mask is a piece of paper laid on to your drawing paper; the pencil can travel up to or over the edge of the paper and when you lift the mask, the color area has a clean, straight edge. You can obtain hard edges using cut paper; torn paper makes a softer edge quality. You can also use thin cardboard, or pre-cut plastic templates such as stencils and French curves.

If it is important to mask off a specific shape or outline, which may be irregular or intricate, you can use a low-tack transparent masking film which adheres to the paper while you work, but lifts cleanly afterward without tearing the surface. You lay a sheet of masking film over the whole image area and cut out the required shape with a craft knife. Carefully handled, the blade does not mark the paper beneath. Low-tack masking tape can also be used to outline shapes; it is available in a choice of widths, and the narrower ones are very flexible for masking curves.

Loose masking

Thin cut or torn paper can be used as a mask either to protect your work from smudging, or to keep an area clear of color while working right up to the edge, without the need for a linear outline.

1 Place the paper mask on the drawing paper and hold it down firmly. Begin by shading lightly over the edges of the mask.

2 Build up the shaded color to the required density, keeping the direction of the pencil marks consistent at each side of the mask.

3 Lift the top corner of the mask to check that you have a clean edge quality and the right intensity of color. Keep the lower edge of the mask in place, so you can just drop it back if you need to rework the color area.

Using masking tape

Masking tape will give a straight edge to create a clean "frame" around a drawing, avoiding the need for a ruler. A hard edge might be used for a geometric structure, or it can be stretched slightly or cut to mask curves.

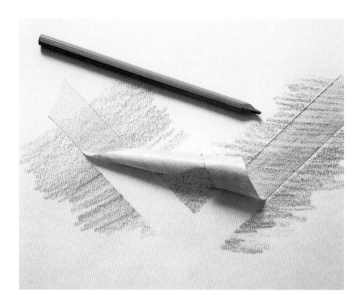

1 Lay down the masking tape evenly, but do not rub too firmly, or you may have trouble lifting it without damaging the paper surface. Shade color over the edges of the tape as you would with paper masks. An advantage of masking tape is that you can work over both sides of the tape at once. When complete, peel back the tape carefully.

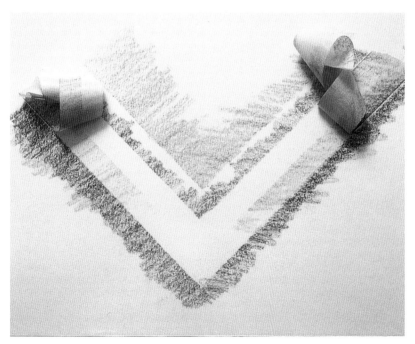

2 If you are overlaying colors, you can use the same mask, or a fresh piece of tape, to cover the paper while you lay the second color.

Using masking film

This is useful for hard-edge, precise work, especially where an image is to be repeated. It has the advantage of being slightly sticky so that it will stay in place while you shade in the cut-out shapes. Practice cutting the stencil with a craft knife, as curves are not always easy to cut accurately.

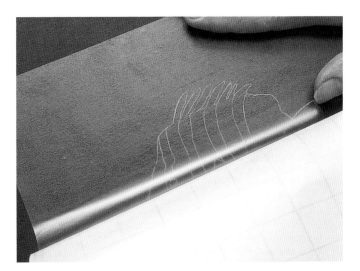

1 Trace the outline of your drawing on paper. Detach the top edge of the masking film from its backing sheet and smooth it down on the paper covering the image area with a border of film all around. Gradually pull back the rest of the backing sheet, smoothing the film across the paper as you go.

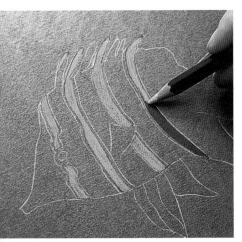

2 Identify the first shapes you are going to color, and cut around them with a sharp craft knife. Lift one corner of the cut film and peel back the shape. Repeat as necessary. Apply the colored pencil to each shape filling it with color up to and over the masked edges.

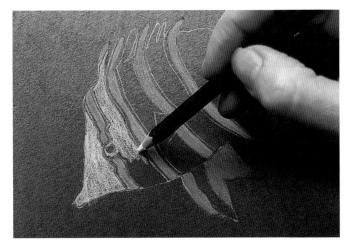

3 When you have completed all areas in one color, move on to the next. Cut and lift the mask sections in sequence, then shade in color.

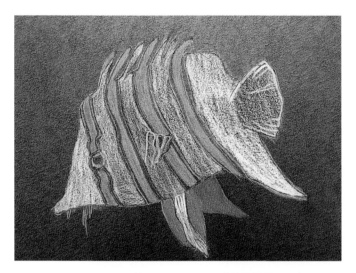

4 At this stage the coloring is complete, and the uncut masking film is still on the paper, causing the black background to look grayed. The next stage is to remove the remaining masking film completely.

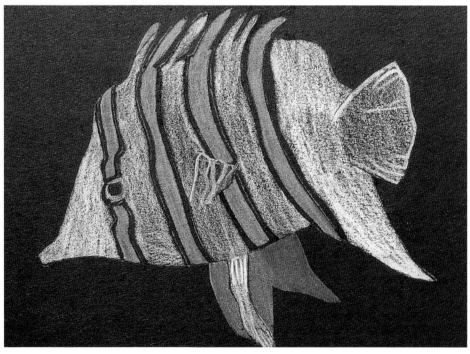

5 Compare the finished effect to step 4. With the mask removed, the edges of the colored areas stand out sharply against the black, making each shape clean and distinct.

Erasing techniques

An eraser can be used both to make corrections and as a drawing tool, although in both cases the process works slightly less well than with graphite pencils. Even so, lightweight strokes are easily eradicated, and in many cases, alterations can be made to regain a surface suitable for reworking. As a drawing tool, use your eraser to create lighter or negative marks on a darker surface, although this will not be effective on washed areas.

The type of eraser you choose will depend on your paper: a kneadable eraser for smooth papers and something firmer, such as a plastic eraser, for more textured ones. Try both and see which you prefer. You can cut a plastic eraser to a suitable size for more precise work, such as the soft feathered edge of animal fur, and kneadable erasers can be pulled into a point. Densely compacted color can be scraped back with a craft knife to open it up a little or to allow for further work with an eraser.

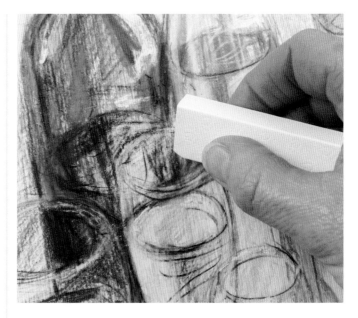

Eraser alterations
The pencil work had become heavy and too dark on the wine glass. An eraser is used to take out some of the excess pigment.

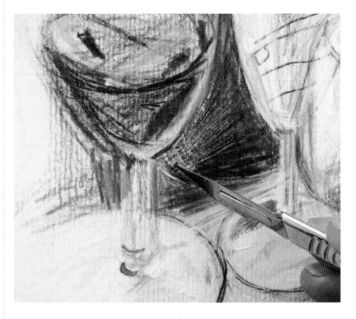

Making alterations with a knife
Similarly, a sharp blade used with care removes pigment that has become too heavy and allows light into the picture.

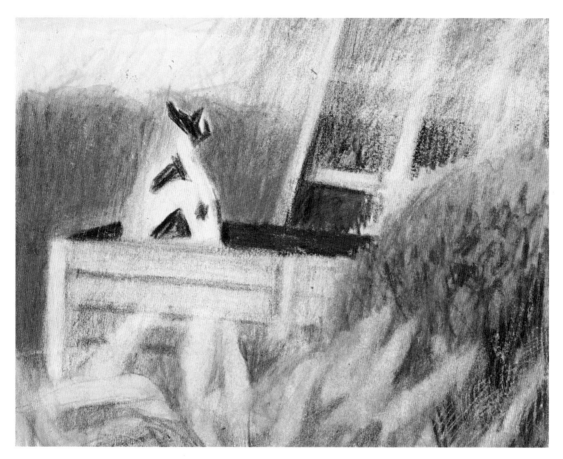

Eraser drawing

For Cat in the Garden, *the artist has used an eraser as a drawing tool to lighten the leaves in the foreground and to lose the definition of the trellis at the right-hand side.*

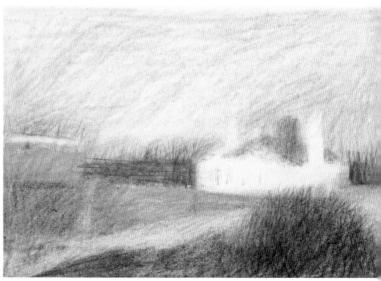

Softening blends

The Pavilion at Marston *shows subtle layering and integral use of an eraser to soften the color blends and to lighten it in places, notably patches of sky and in the foreground.*

Rectifying mistakes

Marks made with water-soluble pencils can be removed by simply wetting them with water and lifting off the resultant "paint" with a rag or paper towel. Repeat several times, as long as you are working on stretched paper (see page 16), and leave to dry thoroughly before reworking. This is often the most effective way to remove unsuccessful drawing. Rather than working too precisely, it is often best to take out a wider area around the problem, leaving a soft or ragged edge, or to work up to a hard edge which might form a natural break in the drawing, so that the new drawing blends in seamlessly. Alternatively, a cotton bud can be used for precision.

White gouache or acrylic could be used to conceal unwanted marks, so long as the surface is busy enough for you to integrate the change in texture.

Searching for perfection

Alteration to preliminary work can often be a bonus, adding texture and depth—or history—to the finished piece. In the search for the perfect line or descriptive mark, reshaping, or even removing can be part of the drawing process. Leave the "wrong" one in until you are sure of the right one to avoid making the same mistake twice. Or leave it in as part of the drawing; the eye will always pick out a true line from previous permutations.

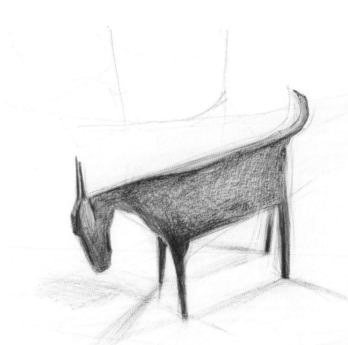

ARTIST'S TIP
Subsequent layers of pencil and wash on an acrylic underpainting will not muddy it, as acrylic is resistant to water. Color can be wiped away to reveal the clear color underneath, perfect for rectifying mistakes.

Exploring structure
This is the initial stage of the later drawing shown on page 71. The drawing in red explores the structure, and the angle of this metal goat has been allowed to tell its story, and indeed plays an important part in conveying a sense of liveliness to this static object.

Making alterations

Alterations are easily disguised if the paper surface is undamaged. Enough pigment can be removed for further work even if the paper is discolored. If the subsequent drawing is to be lighter, a little white paint can be dabbed over to provide a more neutral ground color. This sequence shows you how to implement alteration techniques effectively.

1 The barn on the horizon in this landscape is to be moved slightly to the left. The new position is sketched in and a rag dampened with water is used to gently wipe away most of the unwanted drawing. The drawing is removed around the area to be changed, softening the edge.

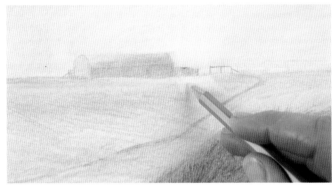

2 When the paper is completely dry, the barn is redrawn and the surrounding area blended into the new work.

3 The new position of the barn makes for a more satisfactory composition.

Underpainting

To underpaint, either lay an all-over ground color before you start, as shown on page 45, using thin acrylic paint, watercolor, or even thin oil or oil pastel, or use the paint as the first stage in the drawing, blocking in the main shapes of your composition, and choosing colors that will play a role in the color relationships of the finished piece.

If you decide on the latter approach, remember that because colored pencils are less opaque than paint, the base layer will affect the covering layer and darken it, so use a lighter shade on top to combat this. Your choice of color depends upon those to be applied later, but in general, choose a base color that will enrich the final layers. For example, you could use a harmonious burnt sienna or warm yellow under a red for a light, bright effect, or you might establish the main light and dark passages in muted monochrome tones, a cool blue, or warm gray.

Underpainting with primer

A primer stops the paper absorbing pigment, and can be used in a considered way to alter the surface texture before painting. The bright white of an acrylic primer can add brightness to translucent or thin layers painted or washed over it, and the dry primer will reveal brush marks which can be integrated within the surface texture, contrasting with any unprimed areas.

1 Underpainting with acrylic primer produces an interesting textured surface to work on with water-soluble pencils. Use a bristle brush and coat the paper with primer straight from the pot. When dry, the brush marks will remain slightly raised, providing a texture that plays an integral role in the look of your finished piece.

2 When colors are shaded over the primer, the brushmarks will show to give a hatched effect.

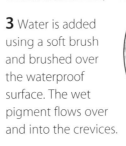

3 Water is added using a soft brush and brushed over the waterproof surface. The wet pigment flows over and into the crevices.

Underpainting with acrylic paint

Ordinary acrylic paint in white or a color is less textural than acylic primer, but will act as a barrier between the paper and subsequent work. Remember: The chosen hue of the paint will affect the colors used however, as shown in the example here.

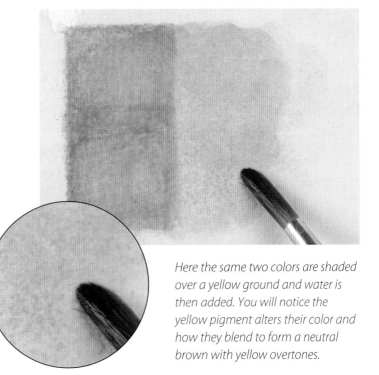

Here the same two colors are shaded over a yellow ground and water is then added. You will notice the yellow pigment alters their color and how they blend to form a neutral brown with yellow overtones.

**Underpainting
with toning colors**
*This hot landscape was under-
painted in acrylic in a bright
turquoise blue for the sea, sky, and
island section and a rich burnt sienna
for the foreground. Although all the
underpainting is well covered, it still
influences the overlaid color, adding
a sense of light and brightness.*

**Underpainting with
contrasting colors**
*In comparison, the
same landscape was
underpainted in a
cool complementary
blue-gray which gives
the completed picture
a slightly muted feel,
although there are
flickers of interest
where the blue is
allowed to show
through, and to
contrast with the
reds and oranges.*

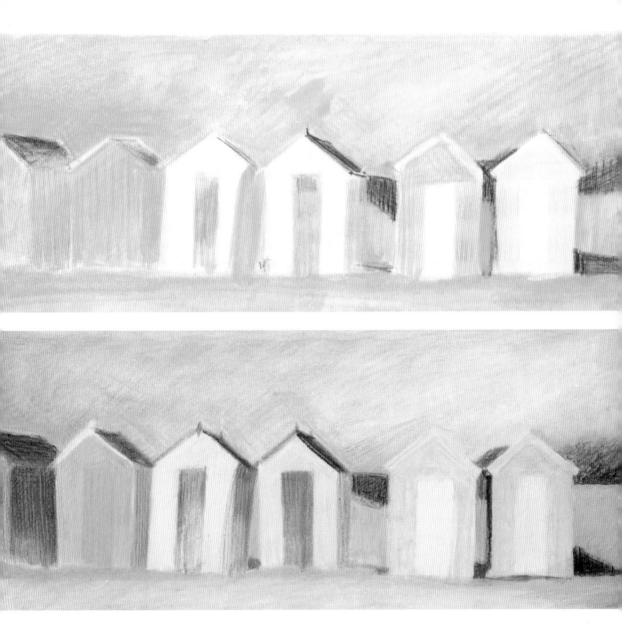

Monochrome underpainting

East Coast Beach Huts *was begun with a monochrome pencil underpainting, using reds of different tonal value blended with water. Only light pressure was used, just enough to indicate the changes in tone before continuing in full color.*

Mixed media

Colored pencils can be a useful addition to other media, adding texture as well as being used to define or clarify a drawing previously worked in pastel or paint. You might try a few different methods, such as working with colored pencil over blended oil pastel, drawing into a colored-paper collage, making a line and wash drawing with a fiber-tipped pen and water-soluble pencils, or combining watercolor.

Oily surfaces

Thin oil paint or oil pastel spread with a little mineral spirit makes a pleasant fluid surface to draw on. The grease seems to mix with the pencil pigment and intensifies the color although it can leave a stain, especially on colored paper, so use only where it will be camouflaged by further work.

Building up in more than one medium

Thin acrylic, gouache, watercolor, and colored inks can all be used in conjunction with pencils to build up the image as well as for under-painting. Color the drawing with water-soluble colored pencils using shading or hatching, and blend with water. Or draw with a combination of colored pencils and one of the several types of pastel available—all contribute varying qualities of color and texture.

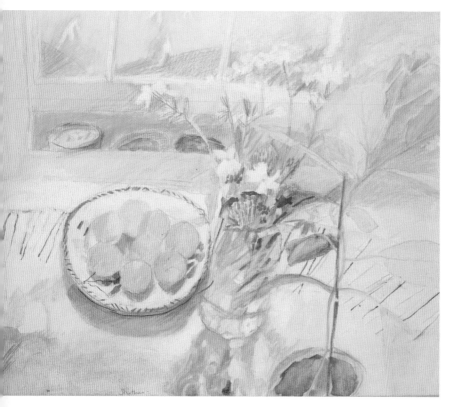

Variety and contrast
In Cricket and Wildflowers *the contrast of the drawn lines and the brushed ones give variety and liveliness. Colored inks, white gouache, and water-soluble pencils are thinly laid, with the white textured ground playing a major role in conveying the airy freshness of the subject matter.*

◀ **Line work** *Both colored pencil and graphite lines have been used in* Table at the Window, *and although minimal, they play an important role, emphasizing geometry and perspective in an otherwise soft-focus oil pastel rendering.*

▼ **Line and wash** *In the pages from a sketchbook, shown right, fiber-tipped pens of different thicknesses were used for the drawings, which were then colored using wet and dry pencil. Further detail was added after the paper had dried.*

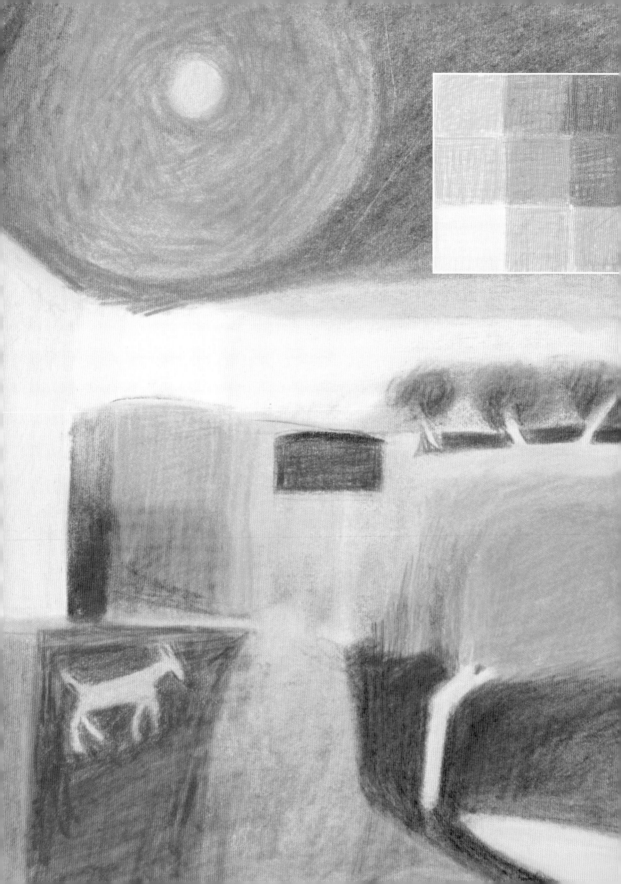

CHAPTER 3

Color

All about color

All colors have three distinctive properties that account for their appearance: hue, tonal value, and saturation. Manufacturers tend to use descriptive and somewhat subjective names for their colors, for example, one will describe a green as "grass green," while another will describe a similar hue as "spring green." In a large box of pencils, you will find many different hues, and many different tones of each one, usually more than you will need, and certainly more than you would wish to carry around. It is therefore important to understand both how these characteristics interact and the relative effect of color so that you can select a few to work with at a time.

Relative tonal value

A gray scale made from "cool" unmixed grays sits alongside unmixed reds, yellows, and blues, demonstrating their relative tonal value. The nature of yellow changes as it becomes darker, whereas the reds and blues retain their identity.

Color terms

Hue: Simply another word for color, referring to the generally accepted color name of an object—grass green, daffodil yellow, poppy red. This may be more specifically described in certain light conditions as yellow green or even as spring green or emerald, further differentiating the hue from other greens.

Tonal value: The relative lightness or darkness of a color. Some colors are intrinsically darker than others; lemon yellow is light in tone while indigo is naturally dark.

Saturation or intensity: Refers to how bright a color is. Prismatic colors are fully saturated, while subdued or muted colors are less vivid and may be referred to as chromatic grays.

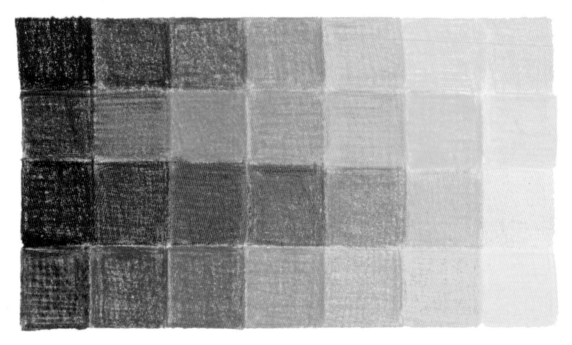

Hue, tonal value, and saturation

Yellows, blues, and reds of differing hue, tonal value, and saturation are grouped together below to show the range within just one color name. The yellows show the least tonal change as yellow quickly loses its identity as it becomes darker, but they all demonstrate wide ranges in hue (where the color is placed on the color circle) and saturation (how bright or how dull they are).

Yellows *If you place the lightest yellow and the darkest against the gray scale on the previous page, you can gauge the fairly narrow breadth of tone compared to that of the lightest and darkest reds and blues.*

Blues *These are easily classified whether they vary in hue from those on the green side of the spectrum, to those juxtaposed with the violet. Tonal variation and purity have little effect on their blueness.*

ARTIST'S TIP

Try grouping your pencils as "reds," "blues," etc. and in doing so you'll become familiar with the range of hues within a group and the variations in tone and intensity.

Reds *These cover the spectrum from red violet through orange and are often not seen as "red" at all, but described as pink, brown, or terracotta.*

Prismatic colors

Prismatic is the term used for the pure colors in the spectrum, the primary and secondary colors as seen in a rainbow: red, orange, yellow, green, blue, indigo, and violet. Three of these are primary colors, which cannot be made by mixing other colors together. The primaries are red, blue, and yellow when dealing with pigment, and red, blue, and green when dealing with light.

This difference is becoming more familiar through the increased use of home computers for color printing. The screen image is in RGB (red, green, and blue), but the images are printed out using inks in CMYK (cyan, magenta, yellow, and black).

Secondary colors are two primaries mixed together; for example, red and yellow make orange. However, no pigment represents a true primary color, as pigments don't behave like colors of light. Instead they tend to have a bias toward one or other of the colors that is next to them on the spectrum. The purest orange will be made from a red and a yellow with a bias towards one or the other, but a whole range of oranges can be made from any number of combinations of reds and yellows.

Mixing primary colors

By combining the primary colors, a number of secondary hues can be obtained. Below are just some examples of the variations that can be achieved through mixing.

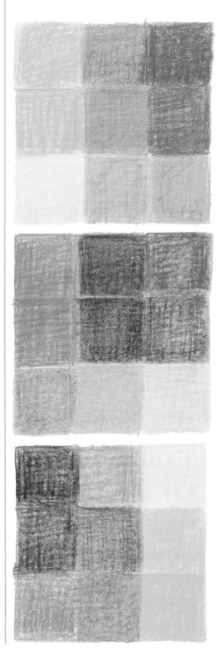

Yellow and red are mixed together to form orange (top row). In the second row, yellow ochre and terracotta form a brownish orange, while in the third a light, greenish yellow and a cool pink combine to form a peachy orange.

Blue and red In the top row, these are mixed to form a dark brownish violet; in the second row they produce a warm red violet, and in the bottom row the light, cool violet and dull pink mix to form a silvery gray.

Blues and yellows Many shades of green can be obtained by mixing blues and yellows. Here they vary from an olive green (top of the second column) through to a rich grass-green (bottom of the second column).

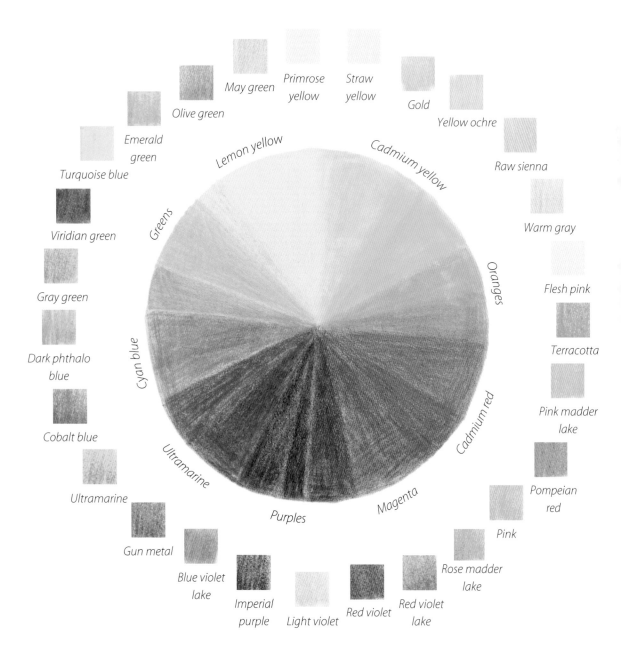

May green

Primrose yellow

Straw yellow

Gold

Olive green

Yellow ochre

Emerald green

Raw sienna

Turquoise blue

Lemon yellow

Cadmium yellow

Warm gray

Greens

Oranges

Viridian green

Flesh pink

Gray green

Cyan blue

Terracotta

Dark phthalo blue

Cadmium red

Pink madder lake

Cobalt blue

Ultramarine

Pompeian red

Ultramarine

Magenta

Pink

Gun metal

Purples

Rose madder lake

Blue violet lake

Imperial purple

Light violet

Red violet

Red violet lake

Color bias Pigments have a bias towards one or other of the adjoining colors of the spectrum. In this color circle (the spectrum joined up) colored pencils from several different brands are grouped to show their color bias.

Warm and cool colors

Colors are often described as warm or cool, but this is a relative term. It's generally understood that, on the color circle, the green, blue, and violet range are the cool colors, while the red, orange, and yellow range are the warm ones. But within these categories, every color has varying degrees of warmth and coolness. For example, magenta, although a red, has a definite blue bias, so is described as a cool red, while vermilion has an orange bias and so is considered to be a warm red.

▾ *Warm palette*
Cliff at Newgale *is worked up from fiber-tipped pen on-the-spot sketches, as a preliminary to a much larger painting. The palette is mostly warm and colors are muted, with contrast found in the relative tonal values.*

Warm and cool primaries

Red and yellow are often described as warm colors, and blue as cool, although there are variations in temperature within each hue. The crimson reds have a blue bias, and are cooler than the more orangey reds, such as cadmium red, while an orangey yellow, such as cadmium yellow, is warmer than the acid lemon yellow. Some blues are purplish, veer toward red, and are therefore warmer than those with a greenish tinge, such as turquoise. Below, three primary colors are shown with the warm version on top and the cooler below.

Warm

Cadmium red Cadmium yellow Ultramarine blue

Cool

Crimson Lake Lemon yellow Cerulean blue

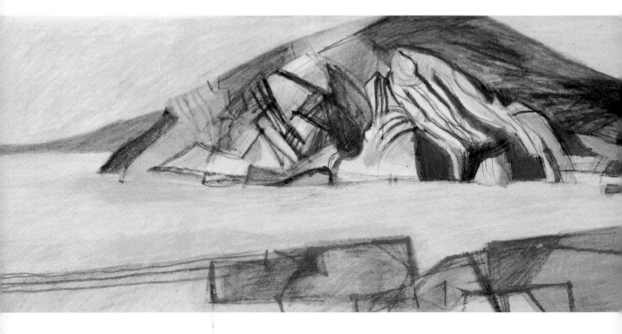

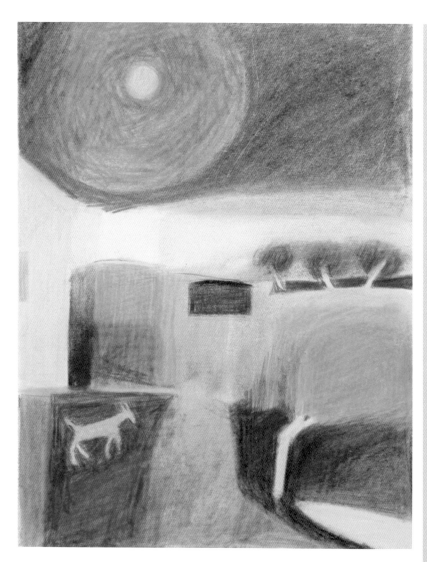

ARTIST'S TIP
If you have a large set of pencils you will find it helpful to line them up in a warm to cool continuum. This will help you sort out the bias of any one color (see page 67). You may find the difference in tonal value confusing at first, but you will soon begin to see whether a so-called neutral color in fact leans toward yellow, blue, or red.

Cool palette
Predominantly cool colors from the crimson to yellow-green part of the spectrum are used in Green Moon and the Goat, *apart from a very small dash of yellow ochre on the extreme left.*

Complementary colors

Complementary colors are those that are opposite one another on the color circle. There are three pairs of these colors: red and green, yellow and mauve, and blue and orange. In their purest state they don't contain any of each other, so provide the greatest contrast when placed side by side. They play an important role in working with color, as they have the effect of enhancing each other.

If you look at paintings in any media you will often see how artists have used these contrasts, bringing mauves into shadows on a yellow object, for example, or using touches of red among greens of foliage.

Complementary colors are also very useful for "knocking back" a color that is too bright, as they become less saturated and less contrasted if overlaid or blended together. A red, for example, could be muted with a light overlay of green. If mixed or overlaid in equal proportions, the identity of each color will be almost lost, producing what is known as a chromatic gray.

Harmonious colors

Any two or three colors that lie next to each other on the color circle will appear harmonious— because they share a common base color, they work well together without jarring. A picture painted predominantly in harmonious colors would be described as having a narrow hue range, and would convey a sense of quietness or calm. Even if prismatic hues, fully saturated red and orange are chosen, the colors are less gaudy than they might be if used in conjunction with similarly saturated complementary turquoise or emerald green.

Harmonious and complementary
An harmonious range, in this case a slightly greenish lemon yellow to turquoise, would sit quietly together; but the study is dominated by the addition of the cool blue, which changes the dynamics and sets up a complementary relationship with the lemon yellow.

Strong harmony
In this study the harmonious element of the color scheme is stronger than the one shown on the left, as both extremes contain blue. This time the complementary contrast, between either the emerald green and dark red-violet or the light gray-violet, is more subtle.

Complementary colors in use

In Goat Nudging Jug, *the strong complementary blue heightens the vivid reds and oranges. Further contrast is generated by mixing these two complementaries together, as seen in the integrated shading of the background strip behind the pears. The lime green of the pear and the red-violet immediately around it set up an echoing diversity.*

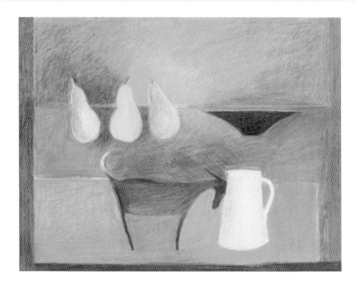

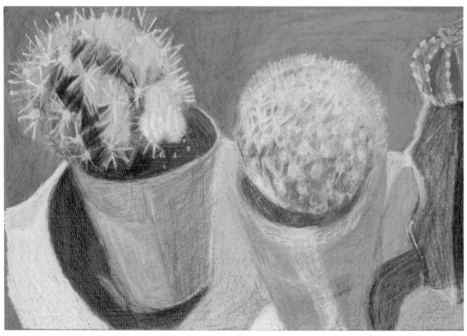

Subtle complementary effects

The complementary contrasts in Cacti, *although evident, are less vivid than in* Goat Nudging Jug *above (the salmon pink with the olive green, and the yellow ochre and raw umber with the gray-violet). The colors appear less intense, partly because of the influence of the green-gray paper, and partly because the palette includes a number of less saturated or intense colors, in places dulled down by mixing complementaries. These can be seen in the greens and reds of the cactus on the right and in the dark patches in and around the flowerpots.*

Color and mood

Color is not only a means of describing what we see—it can also be used expressively to convey a mood or atmosphere. Bright or light colors—known as "high key"—tend to evoke a happy response, whereas dark-toned colors such as browns, deep blues, and purples—"low key"—give a sense of stability and thoughtfulness.

Using harmonious colors, which are those next to one another on the color wheel, create a gentler, more restful atmosphere than strongly contrasting colors such as complementaries (see page 70) or vivid primary colors. In landscape, colors tend to be harmonious—greens, yellows, and blues—indeed you may sometimes need to exaggerate or even invent a contrasting color to avoid dullness. Flower and still-life painters often deliberately set up groups consisting mainly of harmonious colors such as pinks and mauves, with perhaps a touch of a muted complementary or a lighter tone for contrast.

Terracotta

Raw sienna

Olive green

Blue gray

Yellow ochre

Imperial purple

French gray

Flesh pink

High-key palette
A Corner of Green *by Laura Duis, uses a high-key but muted palette, with strong tonal contrasts. The composition is carefully organized, with the light areas established from the beginning.*

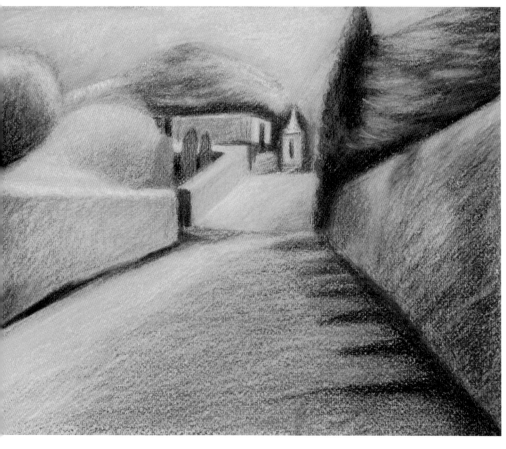

Scarlet

*Cyan or
Spectrum blue*

Ultramarine

Dark violet

Cool gray

Turquoise green

Lemon yellow

Low-key palette

Formal Gardens at Hidcote *is relatively low in key and conveys
an atmosphere of an impending summer storm. The palette is
limited, consisting largely of scarlet, dark violet, ultramarine,
cyan blue, turquoise green, lemon yellow, white, and cool gray.
Scarlet and lemon yellow were blended with water and used for
the initial underpainting, followed by several layers of the mainly
prismatic colors to suggest dark shadows. Highlights were
emphasized by erasing and then redrawing in lemon yellow.*

Lightening and darkening colors

The pressure you use obviously affects the lightness or darkness of the colors, but you can also mix colors on the paper surface to change the tones, even laying light colors over dark (if using water-soluble pencils, you can lighten colors simply by adding water). Although colored pencils are most often worked from light to dark, as they are semi-transparent, white is relatively opaque, as are many of the lighter colors, because they have a higher proportion of white in their make-up than the dark colors. Interesting effects can be achieved by working pale pinks over browns, or pale yellows over greens. When darkening colors, try to avoid too much use of black; this can have a deadening effect. The examples shown on the opposite page will give you some ideas.

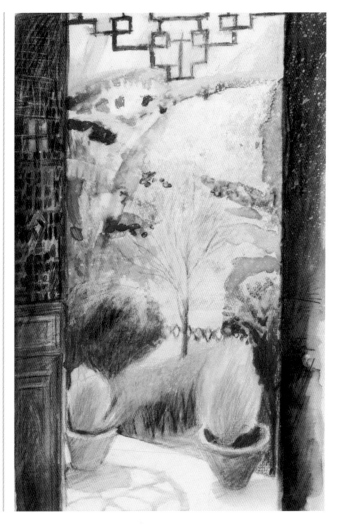

ARTIST'S TIP

Vibrant "darks" are evoked by often surprising mixtures of bright reds, oranges, dark blues, greens, violets; or these can be added to brown or black. The depth of tone will be far greater than that achieved with just a black even with heavy pressure.

Lightening and darkening in context
Garden at Chengdu Museum *is confined to mainly prismatic greens, yellows, blues, and reds in colored pencil and inks, blended with water and overlaid with loose hatching. Some of the light patches have been further lightened with gouache and spattered with bleach, which removed some of the ink. The screen on the left was begun with a pink ink wash and knocked back with pencil work in warm browns, purples, and ultramarine, blended in some places with water. The shadows of the foliage are darkened using ultramarine and some whites and yellows are included. The paper is firm with a fine grain enabling an effective build-up of layers.*

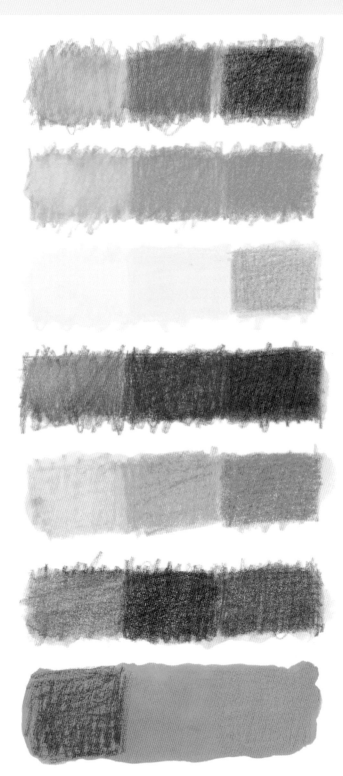

Scarlet lightened with white (left) and darkened with ultramarine (right).

Grass green lightened with lemon yellow (left) and darkened with ultramarine (right).

Lemon yellow lightened with white (left) and with added grass green (right).

Ultramarine lightened with grass green (left) and darkened with burnt umber (right).

Burnt sienna lightened with flesh pink (left) and darkened with ultramarine (right).

Violet lightened with water (left) and darkened with umber (right).

Persimmon pink ink darkened with violet (left) and knocked back with burnt sienna (right).

Overlaying colors

The majority of colored pencil renderings depend upon the effects of overlaying colors. In this way you can achieve richness of hue, tonal density, and contrast, and effective three-dimensional modeling of forms and surface textures. Because colored-pencil marks have a degree of translucency, with applications being influenced by the paper color or other colors beneath, the process of building up a drawing in many layers creates potential for many subtle variations of hue, shade, and texture.

There are many different ways of overlaying colors: you can put one layer of shading over another to modify colors and produce interesting mixtures and gradations; you can build up a network of lines, dashes, and dots to develop complex effects of optical mixing; or you can enliven areas of flat color by overlaying a linear pattern or broken texture that subtly meshes with the original hue.

Color layering provides greater depth and detail in a drawing: you can achieve active color qualities in highlight areas or dark shadows, which intensify effects of light and atmosphere. In a practical sense, overlaying colors is equivalent to mixing paints in a palette: if you don't have the precise hue that you need, you can create it from a blend of two or more colors.

Overlaying water-soluble pencils

1 A pink water-soluble pencil was used for the initial line drawing, to merge quietly with subsequent drawing. Shading in lemon yellow was added and blended with the pink using a wet brush. Highlights were dabbed out with a rag while the color was still wet.

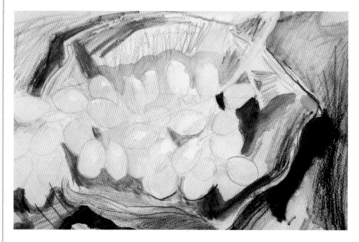

2 Loosely hatched blue pencil describes the form of the dish, and was worked into the shadows. Further loose hatching in black and Prussian blue was used to fill in the "negative" shapes around the dish, the scribbled marks echoing those used for the grapes. Some of the pencil work was merged with water to denote the darker shadows, and more delicately, to produce the pale gray around the grapes in the center.

3 The fluid patterning in the foreground was made by painting water shapes, filling in with a pencil to make a soft pigmented pool, and then pushing the color about with the brush. This was lightened in some areas by lifting out with a rag and added to with pencil and water. Once dry, more pencil work was layered over the top to give a veiled appearance.

4 The grapes were developed with several layers of wet and dry pencil. Loose shading and line drawing reveal the color beneath. Water was used to soften blends, taking care not to lose the linear work altogether, however, the shapes of the grapes are described as much by the drawing of the surrounding shadows, as by these linear marks.

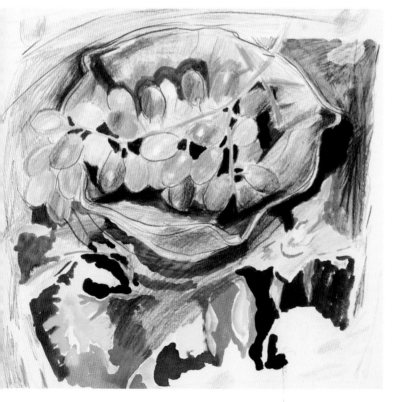

5 *The Blue Dish*
Layering need not result in dense compacted color. Here, open shading and loose watercolor washes are combined with free line drawing.

ARTIST'S TIP
As you begin to learn how colors work together, experiment with overlaying using a very small palette of six colors; two yellows, two reds, and two blues, choosing a warm and cool version of each.

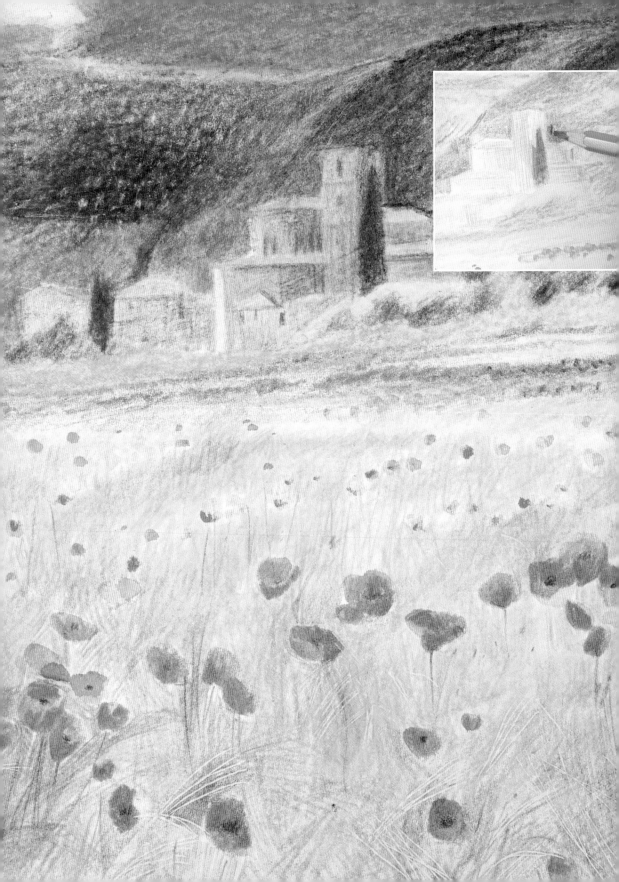

CHAPTER 4

Planning and Procedures

Choosing a viewpoint

If you are working from life rather than from sketches or photographs, the first stage in composing your picture is to decide on your angle of viewing. It is surprising how radically even raising or lowering your own eye level can affect a scene, so try looking at it from both a seated and a standing position—in landscape, a low viewpoint will make more of the foreground, and high one will emphasize the distance. You may also find that a slight shift from one side to another may make a big difference. For example, a group of trees might overlap and thus be hard to read from one angle, but if you move to the right or left they will separate out.

In still life, a high viewpoint will often yield a more dramatic composition than the more common eye-level one, as it organizes the object into a pattern. Try setting up your group on a low table, or even on the floor, and work standing up.

Using a viewfinder

Very few artists are without one of these simple devices. A viewfinder consists of nothing more than a piece of card with a rectangular aperture in the middle, and can be made in minutes. By holding the viewfinder up at various distances from your eye, you can bring the subject close or push it away, and so decide how much to include, and whether cropping would help the composition. You can also work out the best format by holding it up first horizontally and then vertically.

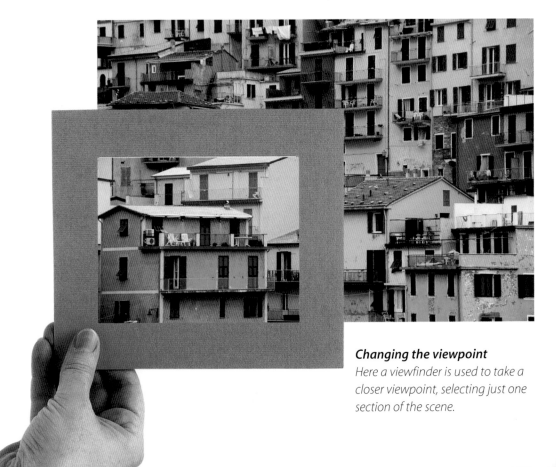

Changing the viewpoint
Here a viewfinder is used to take a closer viewpoint, selecting just one section of the scene.

Changing the emphasis

The viewpoint shown in photo *A* is perfectly satisfactory; it makes a good composition, as the diagonals of the roof and walls lead in to the more distant buildings. However, you might consider changing the emphasis by focusing in more closely on the foreground building to give a more geometric structure to the image (see photo *B*). Use the viewfinder to explore possibilities.

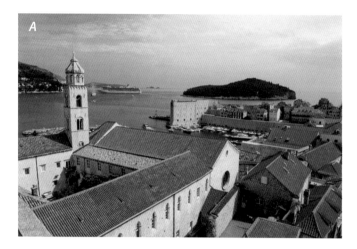

Exploiting shape and texture

In photo *C*, the photographer has aimed at contrasting the strong shape of the cactus with the distant mountains and the diagonals of the clouds, but you could explore the shapes and textures by taking a closer viewpoint and letting the cactus fill the whole of the picture (see photo *D*). In this case, it would be best to omit any distracting background detail.

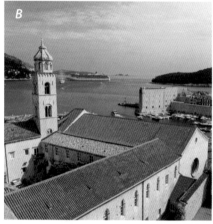

Choosing a format

Once you have decided on your viewpoint, the next stage is to decide on the format of your drawing—whether you want to work on a horizontal rectangle (landscape format) or an upright one (portrait format). Sometimes this will be obvious, but it isn't always, so use your viewfinder again (see page 80) to frame the subject in different ways. If you are working from a photograph, cut two L-shaped pieces of card and move them around on the photo—there is always a temptation to use the same format as the photo, but you may find that by taking a section from the middle of, say, a landscape, you can make a more exciting composition, using an upright shape.

Paper formats

Drawing papers are made in standard-sized rectangles, but you don't have to stick to these proportions—you might prefer a very long rectangle, or even a square, in which case you simply leave some of the paper uncovered. If you do this, it is best to sketch in lines where you intend the drawing to begin and end, otherwise you will be inhibited by the edges of the paper.

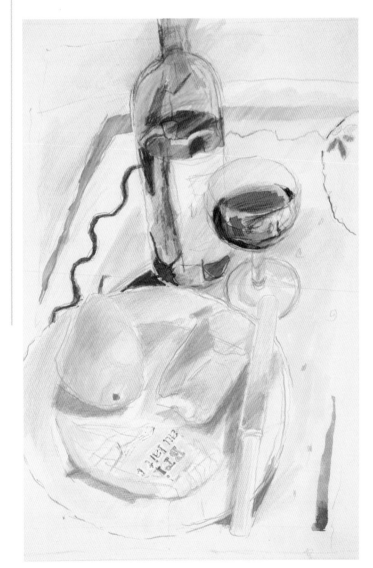

Elongated rectangle
In this piece an unusually tall portrait format has been chosen to accomodate the long diagonals of the knife and table edge. Commissioned for a book cover, the illustration is allowed to bleed freely at the edges.

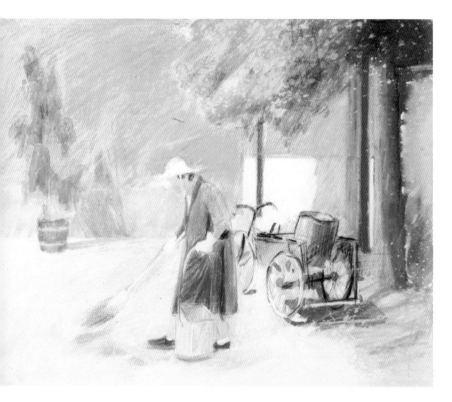

Landscape format
In Street Cleaner, *the classic landscape format makes use of strategically placed horizontals and verticals. It is loosely drawn in colored pencil and inks spattered with bleach, which reinforces its light, airy quality.*

Square format
The Pink House *almost fills the frame, determining its shape. Acrylic and oil pastel have been used boldly in blocks of color, the linear marks of the colored pencil work tying them together in the initial drawing, and also adding texture and movement.*

Composition

There are few hard and fast rules about how to design or compose, a picture, but you should aim for a good balance of shapes and colors so that you create a harmonious whole rather than a series of unrelated elements. To make links between different parts of the image, a common device is to create "echoes," by repeating similar colors and/or shapes from one area to another. In a landscape with a blue sky, you might bring in touches of blue among the greens of grass, and balance a foreground tree with a similarly shaped one in the middle distance.

It is vital to keep the viewer's interest, so don't leave large areas where "nothing is happening," and if there is a dominant feature, avoid placing it too centrally; symmetry tends to split the image into two halves, leaving no center of interest. Don't divide a landscape into equal areas of land and sky—a good ratio would be two thirds to one third of either sky or land. Try also to lead the eye into and around the picture by means of visual signposts. In landscape, curves, or diagonals, which the eye naturally follows, can be used to lead into a focal point—these could take the form of a path or fence running in from the foreground to the middle distance. In still life, folds of drapery can be used to perform the same function.

Making compositional choices

Below is a sequence of sketches made before deciding on a final composition for the finished piece. The objects are moved around, before a horizon line is decided upon.

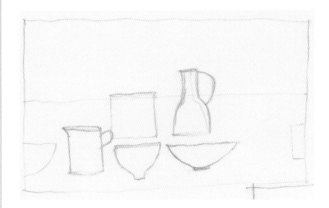

1 In this asymmetrical composition, the horizon line is just above the halfway mark, with most of the detail in the bottom half. The objects are carefully spaced. The eye is drawn diagonally up and to the right of the horizon line to the tall jug, and the two half shapes form a connection by taking your eye from one side and to the other, but not out of the picture.

2 This is far less interesting. It is too heavy at the left-hand side and the eye is drawn along the horizon but has nowhere to go but back again.

3 This lacks cohesion, as the line at the top doesn't relate to the table-top below, but the space could be given distance using directional marks and the layering of color.

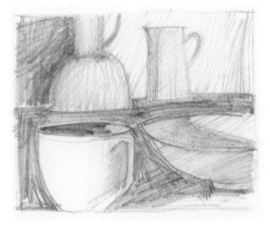

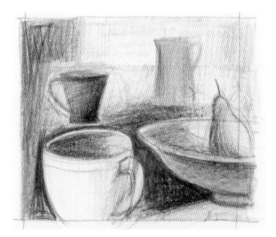

4 This tonal study makes a rough pattern of the light and darks. Almost square in format, the four large objects are used to fill the space, with only one of them seen "whole."

5 The final plan looks at the light sources more carefully. Some of the objects are changed or moved to create a feeling of greater distance and suggestions for color have been included using a limited palette of three or four hues.

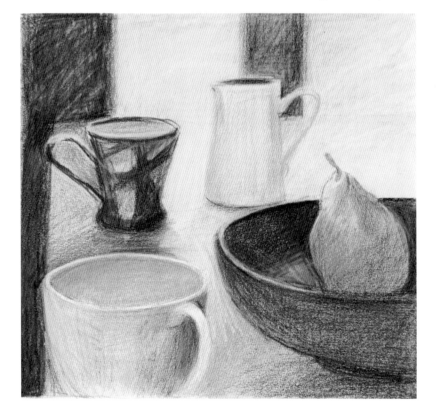

6 In the finished piece, slight changes have been made. The juxtaposition of the objects is reinforced and the way the light falls is clarified. While preliminary sketches can help with compositional choices, it's not always necessary to keep exactly to the plan!

Sketching

Colored pencils are an excellent medium for sketching—clean, lightweight, easily portable, and versatile. You can work rapidly in line only to describe individual shapes and forms, or build up color masses quickly, with loose shading and hatching. Select at least one pencil from each of the main prismatic colors (see page 66) and perhaps a couple of extras, such as an ochre or olive green or cool gray (see Basic palette, page 19), although you will find that for really quick sketching, two or three held ready in your other hand for instant changeover may be enough.

 If you already know your subject and thus have some idea of its color range, you can choose pencil colors accordingly—greens and blues for some landscapes, and reds and browns for others, for example, but remember that you will need the complementaries to your main selection for contrast and nuance (see page 70).

Analysis *Pencil sketches analyzing difficult perspective or detail are useful to take back to the studio. Here, the relative sizes of the chimneys and the lighthouse is important, as is the perspective and the detail of the lantern.*

ARTIST'S TIP
If you intend to make sketches on which to base a finished work, you will need more visual information than if you are simply sketching for its own sake. So if you don't have enough time—or the right colors—to give a full account of the scene, make written notes in the margin of your sketch. And if the weather is changeable, it is also a good idea to carry a camera to record the scene as it was when you began the sketch.

Line drawings *A fiber-tipped pen is handy for simple line drawings. Here the focus is composition, so only the main shapes are extrapolated, and colored pencil is then used to record local color and relative tonal value.*

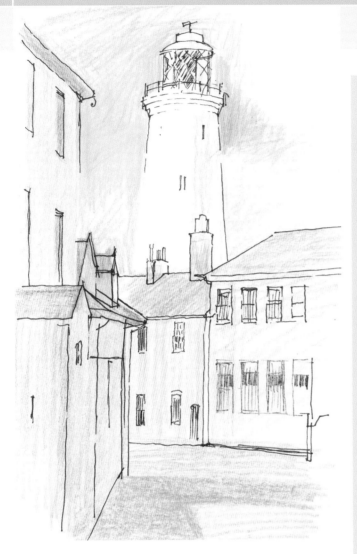

Recording the main elements *This quick sketch shows the lighthouse in situ. It is simply drawn with little extraneous detail, but care has been taken to record the relative proportions of the buildings and the main differences in light and shade.*

THE TRAVELING KIT

If you are out on a sketching trip there are several tools you should consider taking with you. A graphite pencil and an eraser may prove useful, as might a fine-line fiber-tipped pen for quick sketches. You may wish to work on large sheets of paper rather than a sketchbook, in which case a drawing board will be essential— a folding easel is also a great asset. Aside from these extras, essentially, for a day out you will need:

- Basic palette of colored pencils (see page 19)

- Sketchbook (your favorite size, shape, and orientation)

- Bulldog clip or clothes peg to hold the pages open

- Watercolor brush

- Screw-top plastic pot for water

- Paper towels

- Craft knife for sharpening

- Plastic bag or something waterproof to sit on

Drawing styles: Loose

Loose drawing styles will vary between artists, but as a general rule, the whole image is worked on simultaneously, with a gradual build-up to the completed piece. This way of working allows for changes in composition, perspective, or scale to be made easily, as a feeling for the whole image can be seen from the start. Changes can be either disguised or incorporated into the work, and you won't encounter the problem of finding that you have spent hours working on one section only to find that it is too big or too small.

The work can be defined or refined as you wish; the stages in modeling form, enhancing light and shade, or developing detail can be halted or continued at virtually any stage.

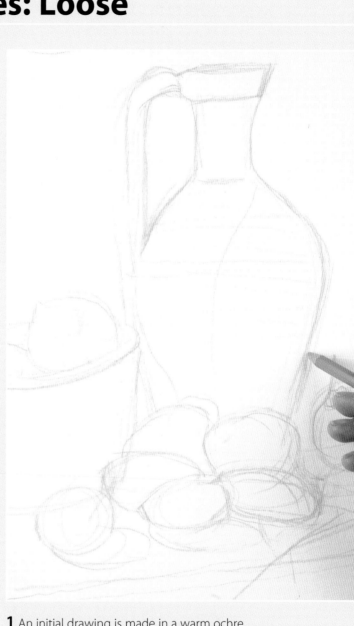

1 An initial drawing is made in a warm ochre pencil using a strong, definite approach. The color will easily blend in to the subsequent drawing and will not inhibit any future changes.

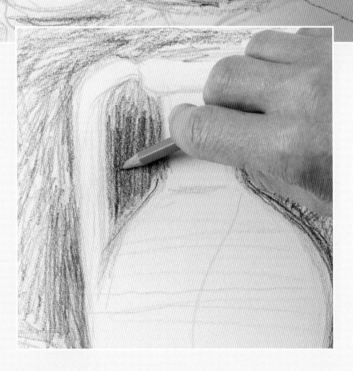

2 Light shading is added in blue and overlaid with red in more shadowy areas. The loose hatching creates a sense of liveliness; the red and blue together suggest a deep warm darkness appropriate to the subject.

3 This close-up shows work in the heavily shaded areas; loose hatching and crosshatching are employed to gradually build the density required.

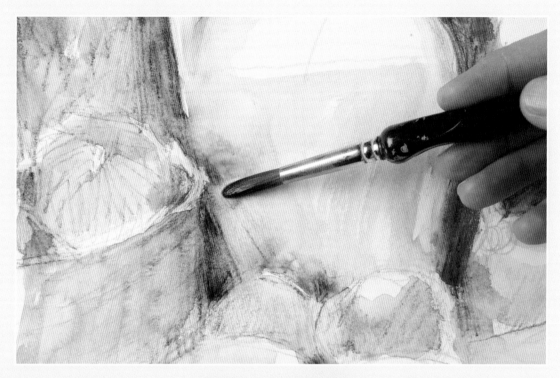

4 Shading is blended with water, deepening the color and tone and providing a smooth surface on which to layer further color when dry.

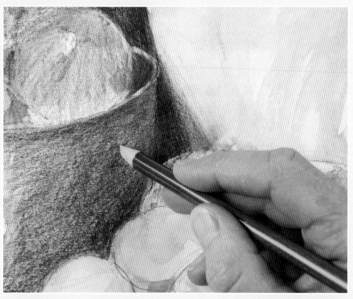

5 Shading and hatching using dry pencil in dark blue is overlaid; but the grainy texture of the paper now impregnated with red still shows through.

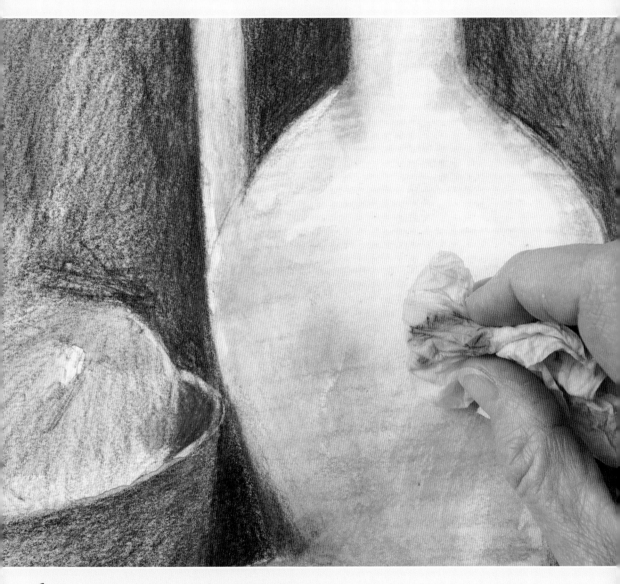

6 New colors are added and yellow ochre is applied to the jar, and then wiped over with a damp paper towel to soften and blend the drawn marks.

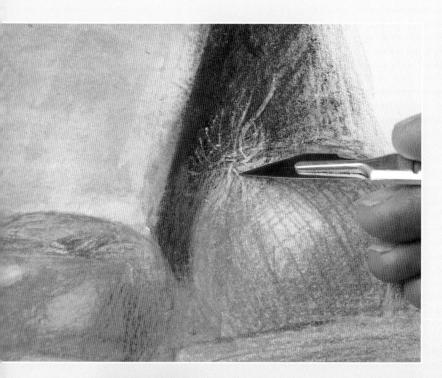

7 The layered area of dark tone behind the onion is sufficiently compacted to allow sgraffito to be used effectively to denote the fine dried roots.

8 The round tomatoes and their shiny skin gradually evolve through a combination of drawing and blending with a brush. The highlights are removed with an eraser on dry paper.

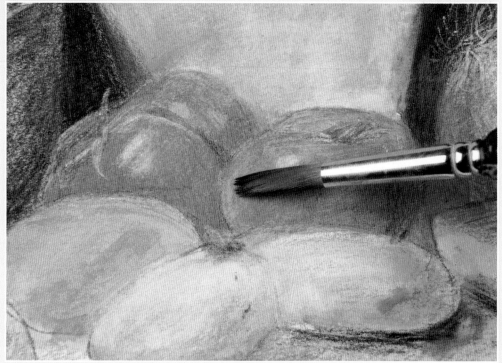

9 Loose, heavy shading partially blended with water in yellow ochre and blue-violet conveys the fairly rough texture of the table top and chopping board. Continuing in the same free manner, details are added to develop form, such as the deeper tone under the potatoes and around the tomatoes.

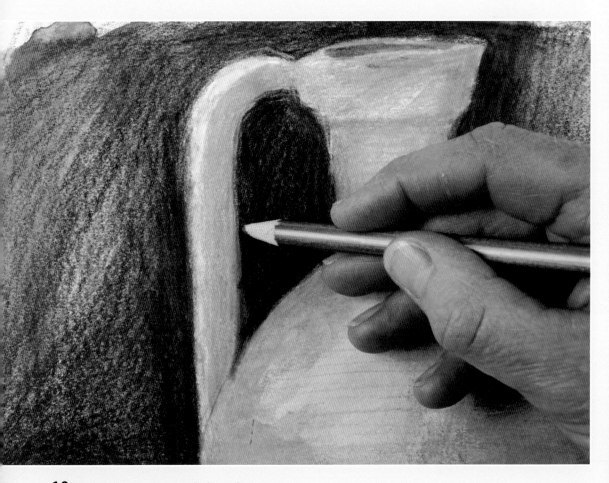

10 Greater contrast is needed in other areas, and here an indigo pencil is used to help the background recede and so give depth to the jar. However, as the shadows recede, more light (in the form of the red underpainting) is allowed to show through.

▶ *Jane Strother*
Stone Jar with Vegetables
The finished picture is both strong and lively, helped by the method of working over the whole picture at once. Surprisingly few colors have been used. Taken from across the spectrum but tending to be warmer variants, predominantly the red-blues—ultramarine, violet, and indigo—yellow ochre, scarlet, and French gray.

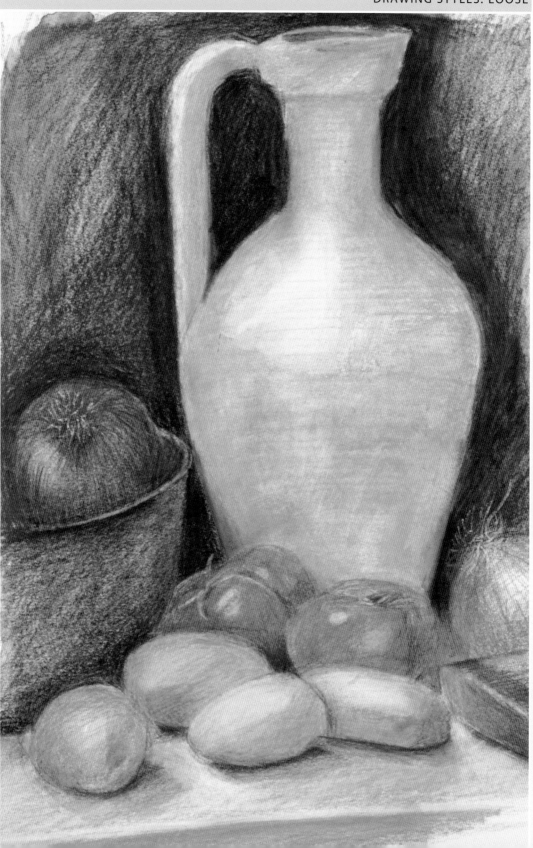

Drawing styles: Tight

Working in a "tight" or controlled manner suggests a methodical way of working from a careful initial drawing through to completion, with little room for changes to be made during the process. Adaptations can be made however, so long as the paper texture isn't altered by too much rubbing out.

In this demonstration, sections are completed separately before moving onto the next, from left to right, as the artist is right handed, to reduce the possibility of smudging.

1 The initial drawing is transferred to the drawing paper using tracing paper, working in line only with a sharp HB pencil and light pressure. The artist concentrates on the detailed parts of the composition.

2 This close-up shows part of the flower area transferred to the drawing paper using graphite pencil. Small blobs of reusable adhesive putty can be used to blot the surface. This prevents the gray graphite discoloring subsequent colored-pencil work.

3 The brickwork and the archway are lightly colored in to judge the effect, avoiding any heavy pressure which could fill the paper.

4 Once the colors are established, layers are built up to achieve the desired effect, with careful modeling of form by observation of shadows and highlights.

5 A battery-operated electric eraser easily removes small circles representing the flower heads without damaging the paper or disturbing the surrounding work.

6 The flowerheads are carefully added in yellow colored pencil, and the surrounding detail is developed using a brown pencil.

Robin Borrett
Abbey Gardens
*In developing this work,
the artist has concentrated on
the texture of the background
trees, slowly increasing the
detail as he moves toward the
foreground. A relatively small
palette has been used—
depth of color and breadth of
hue have been achieved by
layering. An electric eraser or
blob of reusable adhesive
putty easily lifts off color
where alterations are
necessary. Gradually the
whole surface is covered and
painstakingly finished to the
same level of detail.*

Comparing methods: Loose

Here, two artists using differing approaches have reworked the same photograph, *Poppy Fields*, (shown right) in colored pencil. As in the examples on pages 88–101 the obvious point of departure is in the initial drawing. In the loose style, Artist A keeps to the same level of development for the whole picture at all times and uses a greater range of gestural marks whereas Artist B's tight style is very even in its surface quality. Greater use has been made of the effects of color contrast in Artist A's piece, resulting in greater vibrancy and suggested mood.

Poppy Fields *The original photo with its brightly-colored poppies and contrasting blue sky is interpreted by each artist in their own individual way.*

1 After making a very loose sketch to "place" the hillside and the field, the poppies are indicated in red acrylic paint without any further drawing. The paint ensures their redness, as any underlying color would affect the purity of the red.

2 With the poppies in place, the composition is mapped out with a light blue-gray pencil. Blues are lightly hatched to indicate the sky and shaded areas.

3 The overall view shows a color indication for the whole picture area. Even though the shading is very light, at this stage, it is still important for the marks to follow the form of the hillside, and the direction of the grasses.

4 Blending the shading with water removes most of the "white" areas, although the color is still very translucent. The red poppies are kept free of stray brushwork, but the rest is freely worked.

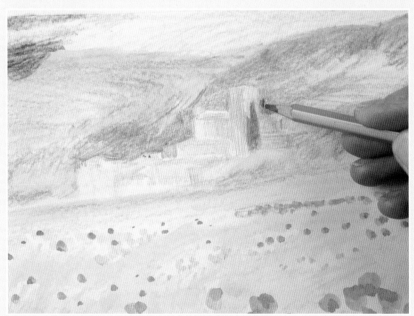

5 The background is worked up in blue, green, gray, and violet, still following the contours and defining the shape of the group of buildings.

6 Continued work on the hillside creates richer color, and the paper grain remains evident through the layering. Some of the drawing describing the monastery needs changing and is easily removed with a damp rag.

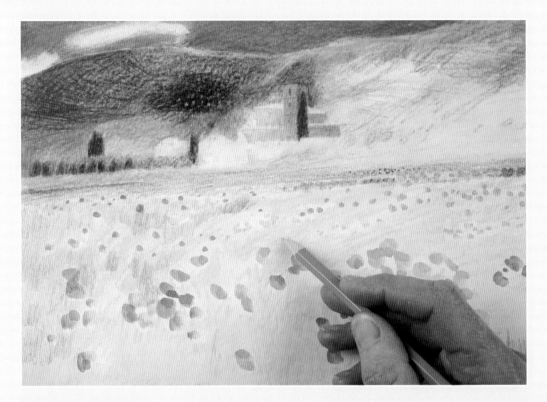

7 Redrawing is left for the moment while the field is developed to the same level as the hillside, with heavier use of yellow and light greens, and some red shading toward the back.

8 A compass point used as an impressing tool over previously colored greens and yellows, is tried as an experiment, to evoke the waving barley in the foreground. The lighter marks are subtly revealed when overlaid with a different shade of green.

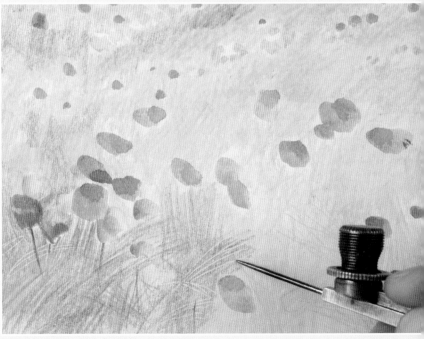

9 The poppy shapes are strengthened with reds and indigo centers, using a pencil occasionally dipped in water. Further drawing in olive green defines the stalks and grasses in the foreground.

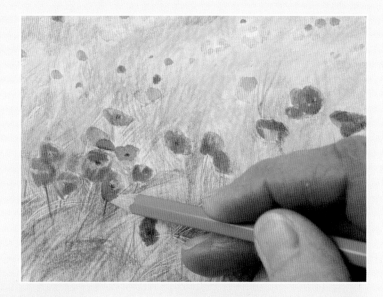

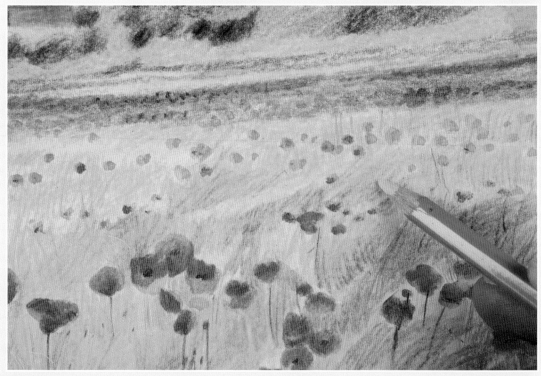

10 A bright warm yellow shaded over the greens ties whole areas of the field together, its translucent quality allows the layering underneath to show through.

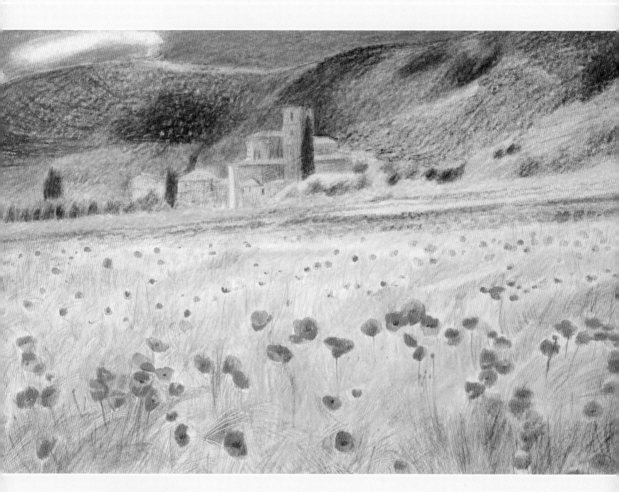

Jane Strother
The Monastery
*In the completed picture the grain of the paper
is evident in the shading of the hills, giving an
appropriate mottled texture, and contrasting
with the more linear textures in the foreground.
The buildings are redrawn, with care taken to keep
the roofs light and bright. There is no white paper
showing; the "white" patches are lightly covered
during one of the initial washes and with a white
pencil (in the sky).*

Comparing methods: Tight

Artist B uses a much tighter style in his recreation of the same photograph. The concentrated approach implemented here results in an intricately worked drawing. Artist B takes time to build up his work section by section, producing an evenly worked, detailed piece, although the color contrasts are much less evident than those displayed in Artist A's interpretation of the same subject.

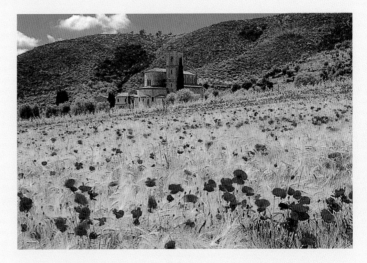

Poppy Fields *The same photograph is reworked by Artist B in a much more detailed and methodical way than Artist A's style.*

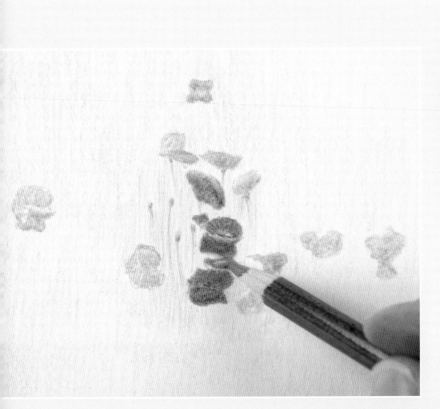

1 Working lightly the artist begins with the foreground after transferring the initial sketch to drawing paper using tracing paper. The main shapes are accurately drawn from the beginning.

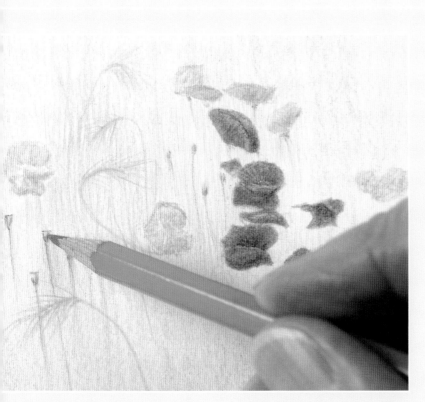

2 The flowerheads, stalks, and grasses of one section are completed before moving on, working from left to right and from front to back. White paper is allowed to show through the hatching. A sharp pencil point is crucial for this degree of detail.

3 After working up the stalks with a green pencil using varied pressure, spaces for more flowerheads are erased using an electric eraser, which takes out exactly the required amount of color.

5 The hillside is built up, slowly and painstakingly copying the texture and colors. The pressure is still light, and hence the white grain of the paper remains, the depth of tone created by layering.

4 In this example, the artist works from front to back, from the field to the undergrowth, and then to the hillside. His more usual approach is to work from left to right, which keeps his hand away from the finished work.

6 The sky begins to complete the picture. The overall feel is of calm and light due to the even pressure and paper grain, which helps to unify the surface.

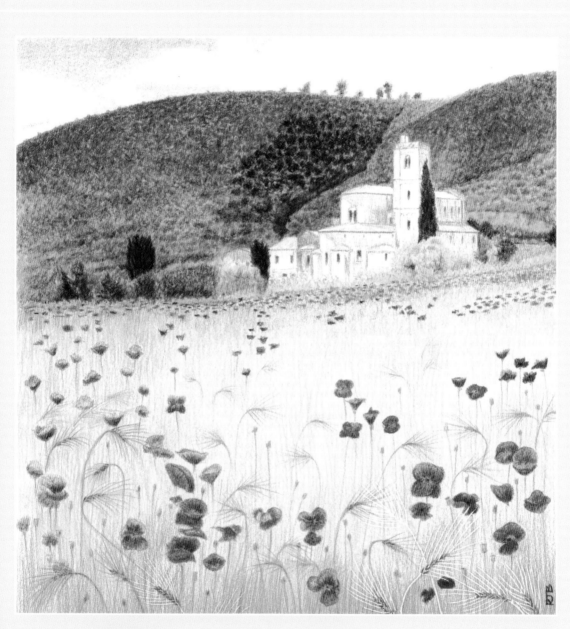

Robin Borrett
Poppy Field
In the final stages, the poppies are given more definition, and a few stalks and heads of wheat added, but care is taken not to overwork the foreground, as this would detract from the focal point of the picture.

CHAPTER 5

Themed Palettes

Buildings

The appearance of buildings is dramatically affected by the light that falls on them. Strong shadows and bright light will define the geometry, the scale, and the detail, all of which will be softer, sometimes even hidden, with lower light level. The character of a building can be revealed by your choice of color and contrast, as well as your use of mark making or composition.

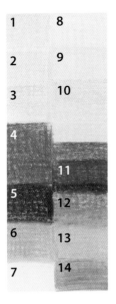

Pure colors
1 Straw yellow
2 Rose pink
3 Sky blue
4 Spectrum blue
5 Ultramarine
6 French gray
7 White

Color mixes
8 = 1 + 2
9 = 2 + 1
10 = 1 + 2 + 3
11 = 4 + 5
12 = 4 + 1
13 = 6 + 1
14 = 4 + 7

Chapel by the sea *A lovely building like this, shining white in the sun against a deep blue sea, asks to be painted—but is it really white? It is easy to misjudge how light the building actually is; in a black and white photo the shaded and sunlit pillars would be very similar in tone to the roof. You will need to choose a color to represent white, in this case, muted light pink, and yellow, sky blue, and cool light gray could be tried.*

Pure colors
1 Gold
2 French gray
3 Cold gray
4 Light violet
5 Rose pink
6 White
7 Light warm gray

Color mixes
8 = 1 + 4 + 5
9 = 2 + 4 + 6
10 = 1 + 7 + 4 + 6
11 = 6 + 7
12 = 4 + 3
13 = 1 + 2
14 = 3 + 6

Cloisters *Muted colors, low in saturation are needed here; the interest should be developed by the observation of perspective and tonal contrast, darks being achieved by layering rather than using ready made dark colors.*

Pure colors
1 Ochre
2 French gray
3 Raw umber
4 Pomperian red
5 Hookers green
6 Turquoise green

Color mixes
7 = 3 + 6
8 = 4 + 3
9 = 4 + 2
10 = 6 + 2 + white
11 = 6 + white
12 = 6 + 1 + white
13 = 5 + 4
14 = 1 + 6

The mine *Two photos have been layered to convey an aged and melancholic feel symbolic of a past industrial landscape. Mixed media can be employed effectively here, a tea bag or sponged coffee used as a ground and then worked on when totally dry with dense pencil hatching in browns, oranges, and olive green.*

Landscapes

For landscape work you can start with the basic palette suggested on page 19 and add further colors depending on whether your landscape is, for example, green and wet or hot and dry. To depict rainy or misty days you will need less tonal contrast and gentler color than for full sunlight, which in turn will alter according to whether the sun is overhead or lower in the sky. When the shadows are shortest, in the middle of the day, color is often bleached out, while when the sun is low, colors appear richer and more saturated.

Pure colors
1 Ochre
2 May green
3 Orange
4 Olive green
5 Prussian blue
6 Ultramarine
7 Dark violet

Color mixes
8 = 6 + white
9 = 7 + 4
10 = 1 + 2
11 = 3 + 1 + 2
12 = 7 + 6 + white
13 = 6 + white

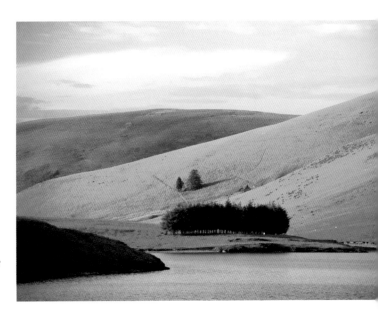

Mountain landscape *Complementary contrasts between the ultramarine blue of the lake and the golden ochre of the sunlit hillside, are on the blue side of the spectrum, the warm ochre being muted by a green undertone in many places. Keeping to one side of the color circle in a painting (there is an absence of obvious red in this image) can give it an overall feeling of calm. To obtain the dark contrast, however, you may need to include a hidden complementary in your mix.*

Pure colors

1 Turquoise green
2 Phthalo blue
3 Olive green
4 Blue violet
5 French gray
6 Warm pink
7 Lemon yellow

Color mixes

8 = 7 + 1
9 = 7 + 1 + 2
10 = 3 + 1
11 = 3 + 2
12 = 4 + 2
13 = 7 + 3
14 = 3 + 5
15 = 6 + 5
16 = 4 + 6
17 = 4 + 7 + 6

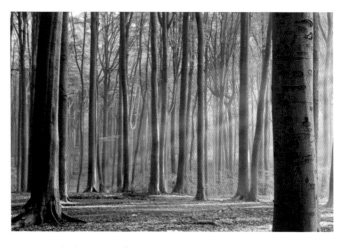

Morning light in the forest *Your palette will need a cool bias to represent the soft muted color in this image. The canopy is blue-green in color, the olive-green-gray trunks can be worked in lemon yellow on the sunlit side, and there are blue-violet shadows on the light-brown leaf cover.*

Pure colors

1 French gray
2 Blue violet
3 Orange
4 Straw yellow
5 Cadmium yellow
6 Warm pink
7 Phthalo blue
8 Ultramarine

Color mixes

9 = 1 + 3
10 = 5 + 3
11 = 5 + 6
12 = 6 + 4
13 = 6 + 2
14 = 2 + 1
15 = 3 + 8
16 = 8 + white
17 = 7 + 1 + white

Sunset, Lake Powell *The only real tonal contrast in this photo is between the darkest shadows in the center and the brightest rocks. Generally the colors are tonally similar and rely on subtle contrasts of high-key color. You will need a palette of light yellow-oranges, pinks, and violets, and for the shadows a light phthalo blue and a warm French gray with some dark blue.*

Portraits

To select a palette for a portrait you will need to observe the sitter in context, as skin colors are much affected by the surroundings and light conditions. For instance, a face with a pale skin tone, lit by a table lamp and the light reflected from a warm red curtain, will look quite different to the same face outdoors on a cold winter's day. You may, of course, choose to place the subject against the light so that the face is in shadow and both the colors and features less distinctive.

Pure colors
1 Sepia
2 Ultramarine

Color mixes
3 = Mixes of 1 + 2 with
varying degrees of pressure.
4 = 3 + white

The girls *Working from a monochrome photo gives you the opportunity to concentrate solely on tonal differences. You may like to try working with two colors, a warm brown and a cool blue for a greater density in the shadows.*

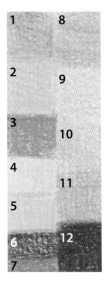

Pure colors

1 Light violet
2 Cold gray
3 Sepia
4 Rose pink
5 Ochre
6 Cobalt blue
7 Pompeian red

Color mixes

8 = 5 + 1
9 = 5 + 2 + 4
10 = 5 + 1 + 2
11 = 7 + 1
12 = 7 + 6

The old man *The bright light shows up the man's wrinkles that give his face such character. Unify the picture with blues and browns, orange, and ochre, and maybe a little violet; the background needs to be dark and densely layered, and the same colors used to describe the expressive lines on his face. The lighter skin coloring could be added afterward almost as a veil, and burnished in places to create a shine.*

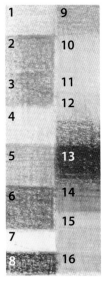

Pure colors

1 Ochre
2 Sepia
3 Pompeian red
4 Rose pink
5 Cold gray
6 Olive green
7 White
8 Ultramarine

Color mixes

9 = 1 + 4 + 2
10 = 1 + 4 + 2 + 7
11 = 6 + 4 + 7
12 = 6 + 7
13 = 6 + 8
14 = 6 + 5
15 = 2 + 4 + 7
16 = 2 + 7

At the window *The features on the left almost disintegrate into the shadows, enhancing their delicacy. For these, use warm browns, yellows, and ochre and some Prussian blue and crimson to complement, both when darkening the tone and for building up clothing and flower detail.*

Skies

Skies can play a major, even predominant role in a landscape composition by their sheer scale; the feeling of "big space" can be controlled by altering the horizon or contrasting color or tone. Bad weather often brings dramatic cloud formations, dark with rain while a shaft of sunlight lights up a ribbon of land. On a bright, windy day, high, fast-moving clouds cause shadows to scud across the land altering the tones and the intensity of color from one moment to the next.

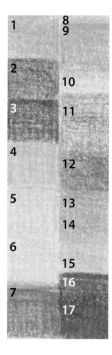

Pure colors
1 Phthalo blue
2 Cobalt blue
3 Hookers green
4 French gray
5 Gold
6 Rose pink
7 Pompeian red

Color mixes
8 = 6 + 5
9 = 6 + 5 + 1
10 = 1 + white
11 = 2 + white
12 = 2 + 1
13 = 4 + 1
14 = 5 + 4 + 1
15 = 5 + 4
16 = 3 + 1
17 = 7 + 3 + 2

Misty morning *The distinction between sky and water is hazy, though emphasized by the clouds' reflections. Use the same cool blue-gray for the water and the haze in the sky, deepen and darken it in the foreground in response to the lighter clear blue at the top left. The golden reflection is a near complementary to the color of the water, with the greatest contrast at the right-hand side. Overlay dark blue or green and red-brown for the trees until you find the depth of color you need, rather than using black.*

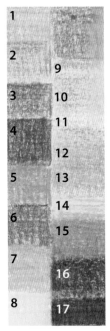

Pure colors

1 French gray
2 Blue violet
3 Phthalo blue
4 Prussian blue
5 Viridian green
6 Cadmium red
7 Warm pink
8 Lemon yellow

Color mixes

9 = 3 + white
10 = 3 + 1 + white
11 = 1 + white
12 = 2 + 7
13 = 8 + 7 + 1
14 = 8 + 5
15 = 4 + 5 + 3
16 = 6 + 3
17 = 4 + 6

Wind For this image, proportion is important, the sky occupies four-fifths of the picture space. The focal point, the almost silhouetted figure, is the darkest element, and you would need to reduce the intensity of the red shirt with Prussian blue, black, or viridian green, or a mixture of all three. Notice how the sky, although lighter, varies in tone across the horizon and is not a clear blue, and that the grasses and other foliage appear indistinct in the low light level.

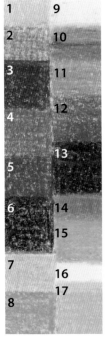

Pure colors

1 Ochre
2 Smalt blue
3 Ultramarine
4 Azure blue
5 Cobalt blue
6 Indigo
7 French gray
8 Emerald green

Color mixes

9 = 2 + 7 + white
10 = 3 + white
11 = 2 + white
12 = 5 + white
13 = 6 + 4
14 = 8 + 6
15 = 8 + 2 + white
16 = 7 + white
17 = 1 + 7

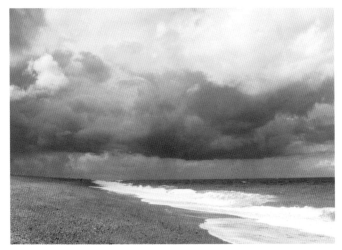

Rain approaching These storm clouds form a deep, dark band just below the halfway line, echoed by the finer, dark blue-green band at the horizon. Try a range of blues and green, layered over each other to create muted hues, and complement with a similarly muted French gray and raw sienna beach.

Still life and flowers

Still life subjects for drawing or painting are most often groups of objects chosen and strategically placed by the artist, but suitable subjects can sometimes be found in situ, for example pebbles on a beach or objects in a greenhouse or garden shed. There is such a wide range of possible subjects that the choice of colors must obviously depend on your own interests.

Pure colors

1 *Light ultramarine*
2 *Magenta*
3 *Scarlet*
4 *Lemon yellow*
5 *Viridian green*
6 *Cyan blue*

Color mixes

7 = 1 + 2
8 = 2 + 3
9 = 2 + 3 + 5
10 = 5 + 4
11 = 4 + 1

Tulips *The pinks and greens in this image will appear clear and bright if worked on bright white paper, beginning with flat shapes, and adding darker tones after an initial blocking in. The vivid contrasts are best obtained from the complementary color contrast of the pinks and greens, and the differences in tonal value.*

Pure colors

1 Ultramarine (W)
2 Phthalo blue (C)
3 Lemon yellow (C)
4 Cadmium yellow (W)
5 Scarlet (W)
6 Magenta (C)
7 Cold gray dark (D)
8 Warm gray (D)
9 Cold gray light (L)
10 French gray (L)

Color mixes

11 = 3 + 6 + 2
12 = 4 + 2 + 6
13 = 6 + 2 + 7 + 4
14 = 4 + 5 + 2 + 8
15 = 10 + 2
16 = 1 + 10
17 = 9 + 3
18 = 9 + 10

Beach pebbles *A large set of pencils may include a number of light (L) and dark (D), cool (C) and warm (W) grays or browns, which will be useful for attempting a group of pebbles like these. Include your basic palette too, though, and lightly shaded and layered complementaries will also produce colorful grays, the layering adding texture to your drawing.*

Pure colors

1 Ochre
2 Warm pink
3 French gray
4 Cold gray
5 Prussian blue
6 Terracotta

Color mixes

7 = 1 + 3
8 = 1 + 6
9 = 2 + 1
10 = 2 + 3
11 = 4 + 2 + 1
12 = 6 + 2

Morning tea *The teacup and newspaper, although subtly lit and with some tonal variation, is really a study in warm, high-key hues. Select a range of warm pinks and browns, an ochre, warm and cool grays, and a blue before you start. Plan out your composition and shade the main shapes lightly with flat color to cover the paper surface before developing form and detail.*

Trees and Foliage

Not only does leaf color change through the year, but the appearance of tree trunks or branches will depend on weather conditions and the variety of the tree. Looking up into the canopy, the leaves will often appear dark against the sky. Color permutations are more or less infinite, so try to bring variety into the greens and browns.

Pure colors

1 Cadmium yellow
2 Naples yellow
3 Lemon yellow
4 Orange
5 Apple green
6 Cobalt blue
7 Dark violet

Color mixes

8 = 2 + 5
9 = 2 + 3
10 = 1 + 3
11 = 1 + 3 + 4
12 = 4 + 3 + 6
13 = 1 + 4
14 = 2 + 7
15 = 1 + 6

Autumn leaves *To maximize the light on the yellow leaves, the glimmer of white light should be kept to a minimum or the yellow will appear too dark in contrast. The yellow can be enhanced by using a purple bias for the almost black branches, and by mixing a little blue with the dull green in the background. The red-orange hue on the right works well with the tonally similar olive greens.*

Pure colors
1 Orange
2 Cadmium yellow
3 Olive green
4 Emerald green
5 Prussian blue
6 Cyan blue
7 Light blue
8 Apple green

Color mixes
9 = 2 + 1
10 = 2 + 1 + 3
11 = 1 + 3
12 = 1 + 3 + 4
13 = 4 + 6
14 = 7 + 8
15 = 2 + 8
16 = 2 + 5
17 = 1 + 5

River bank in fall *A limited palette of two or three greens, a couple of blues, and an orange or two is enough to represent this vibrant composition. Much of the foliage apart from the lime greens, can be layered with an orange underpainting to unify the composition. Overlay this with olive green and grass green and ultramarine for the very dark areas.*

Pure colors
1 May green
2 Turquoise green
3 Lemon yellow
4 French gray
5 Warm pink
6 Raw umber
7 Dark violet

Color mixes
8 = 2 + 3
9 = 2 + 1 + 3
10 = 1 + 2
11 = 4 + 2
12 = 6 + 1
13 = 5 + 6
14 = 5 + 6 + 1
15 = 6 + 7 + 1

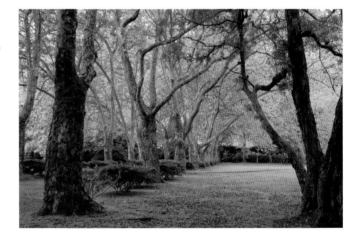

Avenue *Cool light green foliage and green-gray trunks could be set off by contrasting with a warm pink complementary as an underpainting or mixed with raw umber for the leaf litter and darker areas. Make the most of a greater tonal contrast on the left and right with more lemon yellow in the foliage and the addition of dark violet on the trunks.*

Water

An expanse of still water seen at a distance presents a mirror-like surface that will take on the color of the sky, but because water is transparent, when seen close to it will become the color of the lake or river bed, and will also be affected by the color of any substance dissolved in it or carried by it. So your palette can be chosen from an infinite number of colors. Start with the suggested basic palette and add specific hues according to your subject.

Pure colors

1 Warm pink
2 Ochre
3 Phthalo blue
4 Sky blue
5 Ultramarine

Color mixes

6 = 2 + 1
7 = 2 + 5
8 = 3 + 5
9 = 3 + 2 + 5
10 = 4 + 3

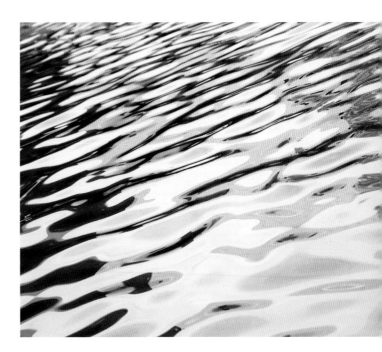

The pool *The rippled reflections in this outdoor pool would be difficult to draw from life, but the photograph freezes the fluid shapes, allowing you to extrapolate a pattern to develop in quite a small range of colors. Observation is the key, once you have explored the shapes revealed in photos, you should find it easier to paint directly from your subject.*

Pure colors

1 White
2 Turquoise blue
3 Ultramarine
4 Dark violet
5 Raw sienna
6 Cold gray
7 Hookers green
8 Orange

Color mixes

9 = 1 + 2
10 = 1 + 2 + 5
11 = 6 + 2
12 = 6 + 2 + 3
13 = 4 + 3
14 = 4 + 6 + 7
15 = 8 + 5 + 7
16 = 8 + 5

High tide *Bright whites need to be seen in relation to the tonal value of the colors surrounding them. In this image the white spray is the focal point and needs to be enhanced by strong contrast with the hues and tones of the sea. Even the foam is surprisingly dark, so use dark blue-greens and cool browns for the sea, with creamy white and warm light gray for the spray.*

Pure colors

1 Ochre
2 Turquoise green
3 Emerald green
4 Dark violet
5 Red violet
6 Hookers green

Color mixes

7 = 1 + 2
8 = 2 + 3
9 = 6 + 3
10 = 4 + 3
11 = 4 + 6
12 = 5 + 2

Shallows *This study in green can be represented by close observation of the fluid shapes and patterns, and the changes in tone. Use blue-greens and a little yellow ochre with a complementary red or red-violet to enhance the darker patches of the scene.*

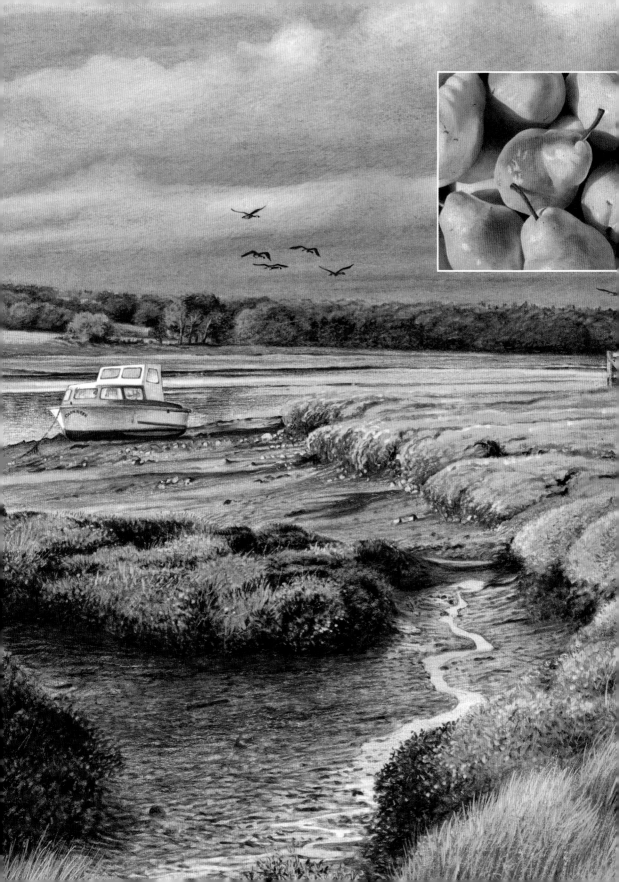

CHAPTER 6

Gallery

Landscape and seascape

The Wave
by K. Scott McGregor
*Working mainly with water-soluble pencils,
and using layering and blending techniques,
the artist has given a wonderfully accurate
account of the breaking wave and the
plumes of spray. The picture is full of life and
movement due to the use of repeated curves
and strong tonal contrasts.*

Morning Surf, Monhegan Island
by Kendra Bidwell Ferreira
By focusing in closely on a small section of the rocks and water, the artist has produced a wonderful patterned effect reminiscent of a lacy fabric. Minimal layering of color has been used—the white foam and waves are areas of the paper which were sketched in and have been left white. The color is juxtaposed and mixed by the viewer's eye and the strong tonal contrasts enhance the delicate fragility of the swirling water.

Perpetual
by Jeff George
In this atmospheric work, dry colored pencils have been used more as a painting than a drawing medium; careful, painstaking layering and blending have ensured that no pencil marks are visible. The artist has worked on blue paper to give an overall cool blue cast to the painting, and to avoid the reserved highlights on the rocks from appearing too bright.

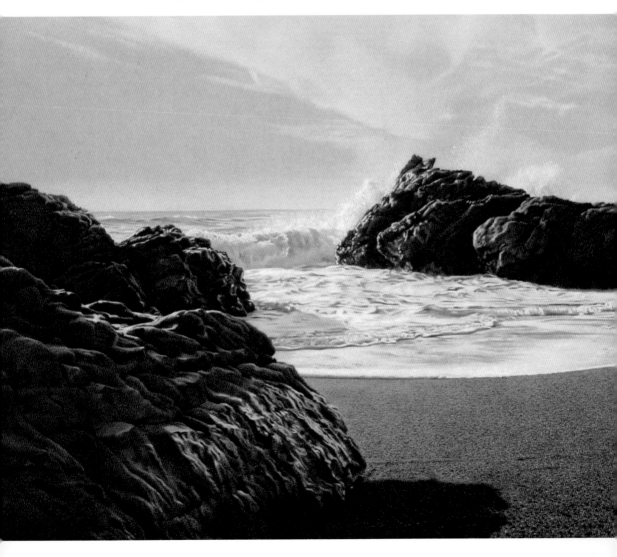

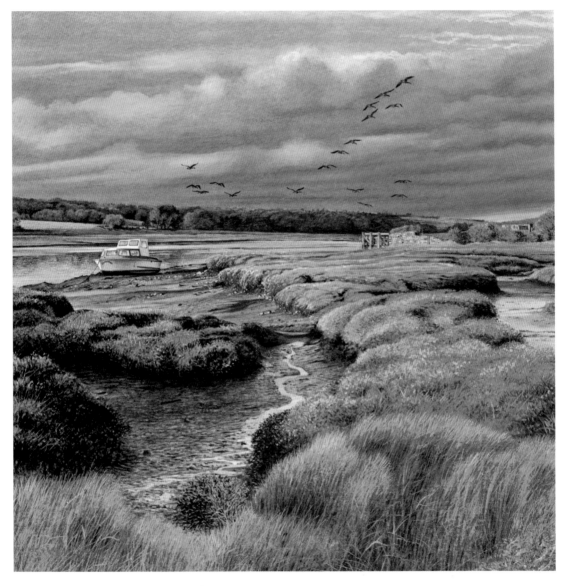

Evening Flight, Hook Quay

by Graham Brace

This scene was worked in the studio from notes, observations, and photographs. It was begun with a colored ground laid with pastel pencils rubbed and blended into the surface and then fixed, and continued with two different brands of dry colored pencils, one softer and waxier than the other. The fine detail in the vegetation was achieved by scratching out, together with some fine brushwork in gouache paint.

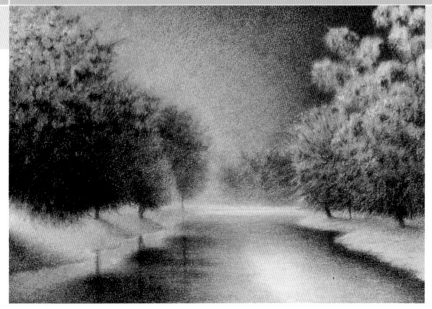

Equanimity
by Susan L. Brooks
The artist has chosen to work on sanded paper designed for pastel work, which grips the pigment very firmly and allows for a considerable build-up of colors. The color scheme is a simple but highly dramatic one, based on the yellow/violet complementary contrast.

Riparian Winter
by Richard McDaniel
An unusually wide, shallow landscape format has been chosen for this image to make the most of the lovely sweep of the river running from foreground to middle distance. The tones and colors have been built up by several layers of hatching and crosshatching, but blending has been kept to a minimum in order for the pencil marks to play a part in the composition.

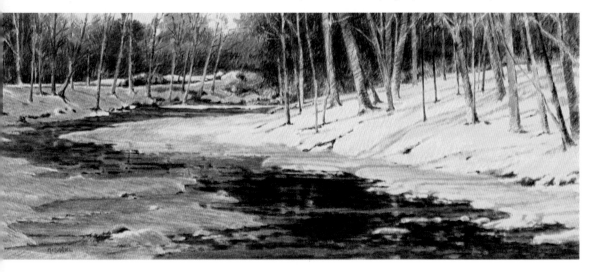

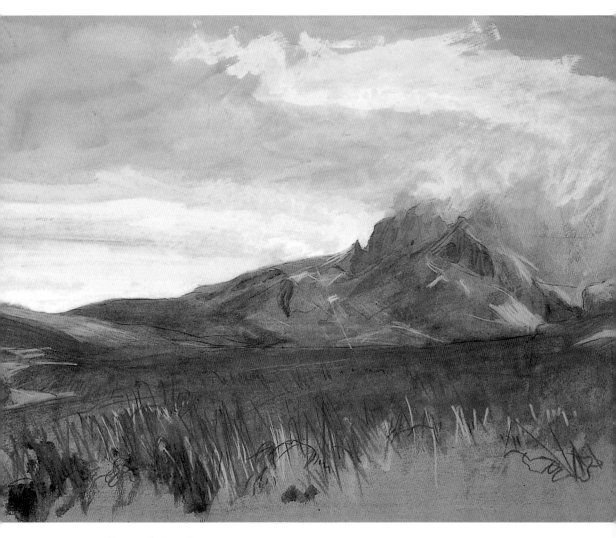

Mountain Landscape
by Mark Hudson
The painting was begun with light washes of watercolor to form the ground (this is still visible in the immediate foreground). Rough shading and hatching with colored pencils contribute to the atmospherics of the sky, while linear work in the foreground suggests the textures of the grass. The colors chosen are natural hues that both reflect the subject and create a harmonious mood.

A View Near Biggin Hill
by John Townend
The style used here is bold and free. A strong sense of rhythm and movement is achieved through bold outlines defining individual forms together with multi-directional hatching and crosshatching, especially noticeable in the foreground.

Forest Light
by Mike Pease
In this piece, tonal contrasts are used to create the strong light effect. Simultaneously, the muted background colors and small, intricate shapes, give a misty, fragile quality to the rendering.

Stone Summerhouse—Belvoir Castle
by Robin Borrett

The textures play a major part in this picture. The three main areas of grass, stone wall, and flowers each have a specific texture. The early layers were kept light, and bolder and darker colors were added to create form. Scratching out the pigment and impressing techniques were used in the area at the top of the steps to accurately render the form of the twigs and branches in the shrubbery.

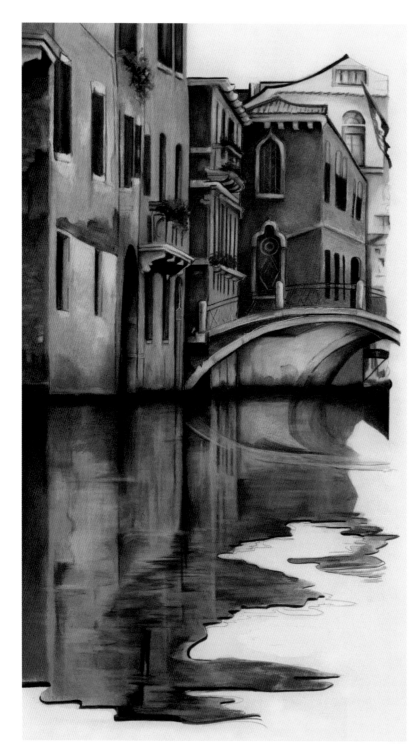

Reflections of Venice
by Vera Curnow
The artist has used an interesting technique for this rendering. Working on illustration board, she covered the whole surface with low-tack adhesive film, cutting and peeling it away section by section as she worked with wax-based colored pencils and mineral spirits. In the final stages, detail was added with dry pencils.

Nature

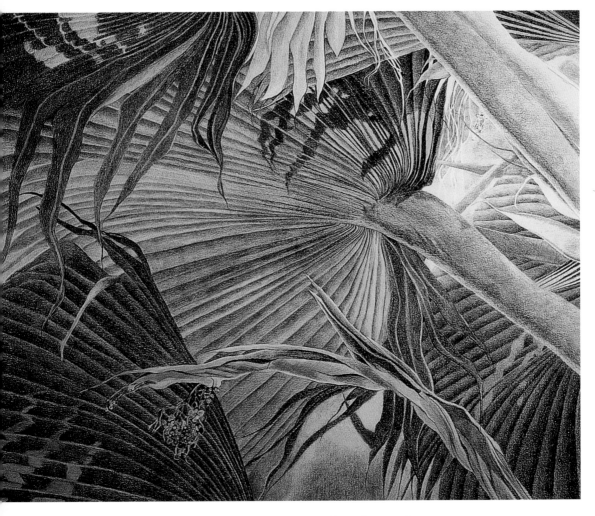

The Palm Jungle
by Dyanne Locati
*For this powerful image, which has strong
abstract-pattern qualities, the artist has used even
shading to build up the shapes and forms and
achieve subtle variations of tone and color. The
grain of the paper allows the applied colors to
"breathe," adding sparkle to the rendering.*

Tulips
by Angela Morgan
The complex arrangement of petals and leaves that forms this composition is created with a faint pencil outline. Although the overall effect is light and fresh, the pencil colors have been laid with a confident, free technique. The orange tulips are a vibrant blend of yellow, orange, and red pencils, and the more delicate pinks are similarly described with varying tones of the basic hue.

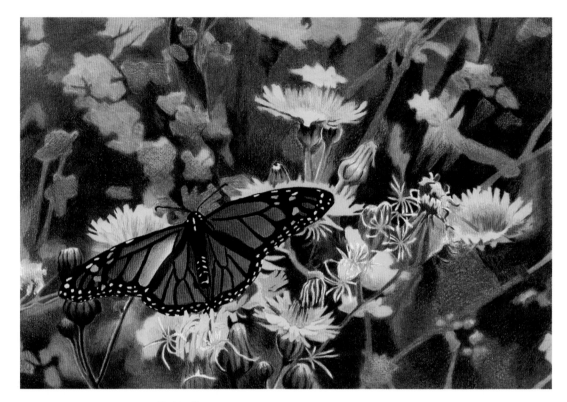

Butterfly
by Kendra Bidwell Ferreira

When depicting small-scale objects such as these, accuracy is essential; an impressionistic approach would not convey the essence of the subject. The butterfly has been very carefully drawn, as have the flowerheads, and built up in layers to achieve depth of color and tone. Notice that the flowers at the top have been treated in less detail, while those just behind the butterfly are in sharp focus.

Buffy the Cat

by Richard Childs

This is one of a number of studies of this cat, and here the artist has focused closely on the face, creating a highly dramatic and eye-catching composition. The whiskers were achieved by impressing lines with an inkless ballpoint pen and then working many layers of soft colored pencil on top.

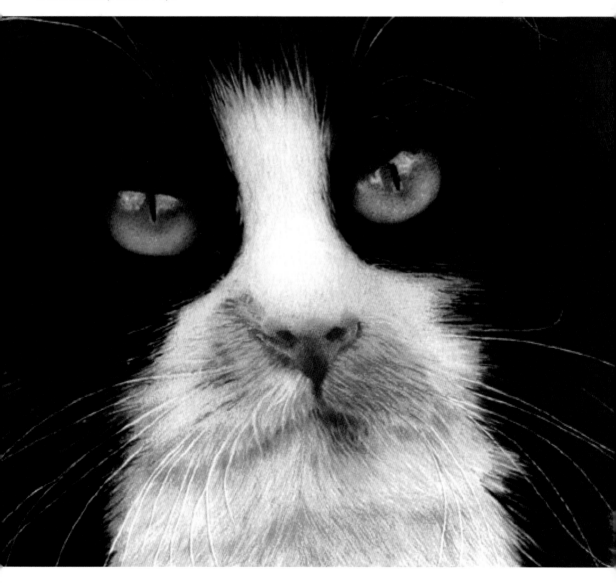

Spectrum
by Vera Curnow
*Both the red/green complementary contrast and tonal
counterchange have been exploited here, with an excellent
balance of light, dark, and middle tones. Notice especially
the pattern made by the "negative shapes" behind the
buds and stems on the left. The artist has used wax-based
colored pencils blended with mineral spirits, and has given
the work a glossy finish by applying thick fixative.*

Nina's Rose
by John Hayes

This piece was drawn from an enlarged photograph, using a light box. The darkest tones were added first using small overlapping circular strokes, decreasing the pressure toward the lightest area of each tone. A colorless blending pencil was used to blend the colored layers in the same circular motion. Further blending was undertaken with a paper stump (torchon) dipped in solvent. This eradicated any colored-pencil lines, before a layer of white was added and rubbed gently with a paper towel, helping to create the carefully placed highlights. A black gouache background and light layer of fixative sharpens the finished picture.

Sweet Chestnut
by Elisabeth Aubury
This drawing is in the tradition of botanical illustration, with each element arranged so that all are clearly visible and also make an attractive pattern on the page. The artist has used dry colored pencils with layering and blending methods, and has lifted out some highlights with an eraser.

Eucalyptus by Steve Taylor
The leaf shapes in this piece are simple forms, and so a
controlled tonal balance is essential to the complexity of the
rendering. The artist has chosen gentle watercolor hues
which have been strengthened with light pencil shading.
Paper has been left bare or very lightly painted where veins
and stems show white against the color.

Roses and Apples

by Robert Maddison
This drawing addresses a traditional still life subject,
but the elements and arrangement are challenging.
Intense colors and reflective surfaces are paired with
complex patterns and shapes. Here, the artist has
focused on the subjects' abstract qualities to
emphasize the contrasts in the composition.

Fox in Autumn
by Steve Taylor
*Most of the modeling and atmospheric description
is created here with watercolor, subtly modified with
water-soluble pencils. The movement is expressed by
the fluid lines of the fox—the angle of its body and
the downward thrust of the head, as well as the
more obvious motion of its legs and paws.*

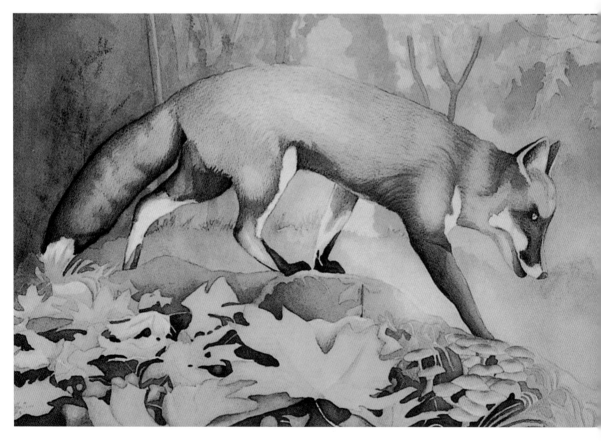

Border Collie
by Richard Lovesey
*In this lovely drawing, the artist has captured
both the texture of the hair and the expression
of the dog—it is very much a portrait of a
specific animal rather than just a dog.*

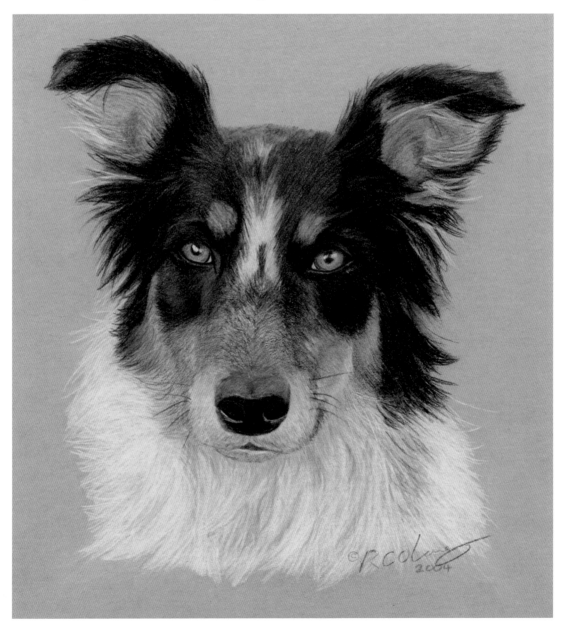

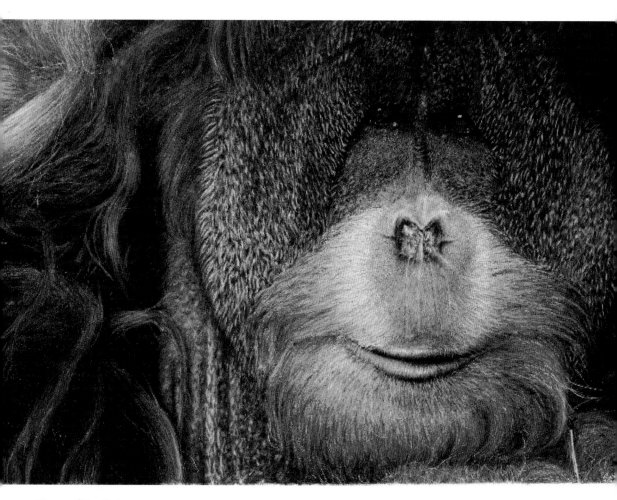

Hope of Sepilok
by Richard Childs

This wonderful drawing was inspired by a visit to the orangutan sanctuary in North Borneo, and was done from a photograph. The textures of the animal's fur was built up with many layers of soft colored pencils, which were then burnished with hard strokes of a colorless blender in the direction of the fur. White, cream, and French grays were then laid on top for the wispy hairs.

Bad Language
by Robin Borrett
This picture illustrates how colored pencils work so well when illustrating animals. Using a fine point, the artist has created the animal's coat with accurate detail. The bridle was treated differently by burnishing, creating a smoother surface without showing the pencil strokes.

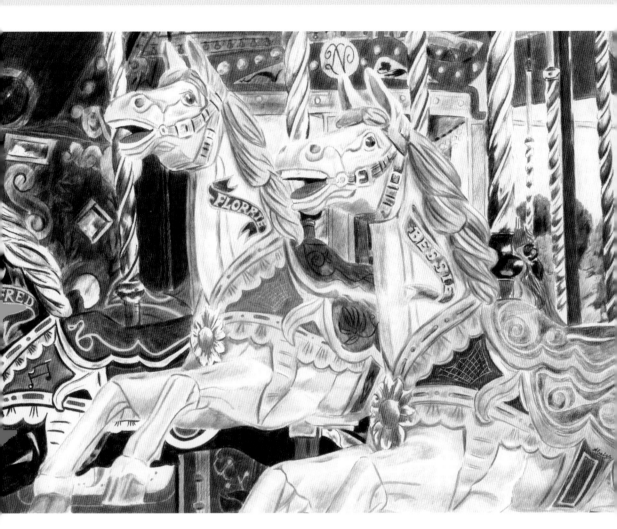

The Merry-Go-Round
by Angela Cater

*For the artist, this was very much a nostalgic piece, as
she spent many happy times on the merry-go-round
with her Grandmother. Dry colored pencils were used
to build the color in layers, working from light to dark.
The detail on the saddles was impressed into the paper
using an empty ballpoint pen, so the white paper was
then retained when color was overlaid.*

Still life

Sweet cherries

by Kendra Bidwell Ferreira
This piece was begun with a wash of indigo blue colored pencil and solvent for the plate. Light red colored pencil and solvent were then used as an underpainting for some areas of the cherries.

Beginning with a wash helps to eliminate some of the texture of the paper, although white paper was left to create the carefully-placed highlights on the cherries. Layers of dry pencil were then added for depth of tone and to deepen the contrast with the plate.

Pears

by Kendra Bidwell Ferreira
The artist has organized both the objects and the lighting to ensure that cast shadows play an important role in this image. Notice how the contrast between warm and cool colors is used to build up the forms, rather than relying on tone.

Bowl with Apples

by Peter Woof
This is an interesting example of cropping to make a more powerful composition. The central area of the plate, with the strong pattern framed by the sweeping curve, provides the perfect background for the gently colored, rounded forms of the apples. The artist has used soft, waxy colored pencils, which facilitate blending, and has worked on heavy watercolor paper.

Death Row
by Jeff George
This piece was completed section by section: the woodgrain perimeter first, followed by the interior of the matchbox, then the colorful matchheads, the matchsticks, and finally the box exterior. In each segment the darker layers were added first, before working toward the lighter values.

Empty Nest
by Jeff George
*Empty Nest has been
worked on a black
illustration board.
The door is composed of
three different layers of
white colored pencil,
a hard lead white pencil to
establish the local color of
the door, a slightly softer,
more opaque white pencil
to enhance and enrich the
details, and then a final
layer of soft pencil to
achieve the brightest
highlights. Blues and
lavenders were then layered
on top to give tints of color,
and to increase contrast
and drama, a black pencil
was used to develop
small shadow details.*

Portraits

Self Portrait
by John Townend
The strong contrasts of black and red, together with the complementary contrasts of green shadow areas, creates a powerful, almost aggressive effect. The mood is emphasized by the busy pencils marks, weaving over and around each other to describe form and texture.

Portrait of Caith
by Katriona Chapman
*The mood of this portrait is serene
and gentle, as befits the subject. The
artist has used watercolor pencils on
board, skillfully blending to achieve
soft gradations of tone and color.*

CHAPTER 7

Subjects

Landscapes

Beach with palm tree *This subject demands a painterly approach, using water-soluble pencils or blending with solvent for the background and beach. Use a clear, light turquoise green and raw sienna together with more muted colors such as grays and blue-violet. The tree can be described with more linear marks.*

Evening on the water *The warm oranges of the tulips in the foreground can be echoed subtly throughout the picture area, hinting at the warmth of the evening light bathing the promontory in the middle distance, the trees, and the water. Warm pinks and ochres will modify and unify the greens and blues, allowing the pure cobalt blue of the boat to stand out in contrast.*

Autumn colors *Underpainting in lemon yellow would unify the colors in this composition, enhancing the bright orange and making a good ground color for the trees. Keep the yellow clean and fresh, and build up the foliage with small strokes of well-sharpened pencils to create a stippled effect, layering dark colors over light. If necessary small patches of light can be revealed with sgraffito.*

Desert *Blending two complementaries gradually reduces the intensity of each. To begin, copy this image in cyan blue and red-orange, varying the pressure. Add yellow for the highlights and perhaps burnt sienna, but keep your palette to a minimum.*

Lakeside *The lakeside is mirrored almost perfectly. Use tracing or transfer paper to transfer the image. Once the colors have been built up to a compacted surface, burnishing or work with an eraser will help you achieve the blurred effect in the water. For the clouds, you might try mixing white gouache with a little wet color rather than leaving the paper white. The intense blue should be built up by layering dense color, working on a bright white paper for the best results.*

The Beck *The translucency of water is not easy to achieve. Start with the underlying colors—the browns, yellows, and grays—and once the surface is compacted, burnish with white or a selection of pale tints. Very thin acrylic, mixed with a medium rather than water, could be applied with a brush or a sponge, but it shouldn't become too wet. Work quickly, as the wet paint will "melt" the pencil marks, making the mixture difficult to control.*

Nature

Poppy The calyx and the stamens probably need to be worked up first from a carefully observed drawing in order to keep the image crisp. Use well-sharpened pencils for this area to provide a contrast with the softer petals, which could be worked with blended water-soluble pencils and added linear work for the tonal detail.

White flower with bee *You will need no more than a handful of pencils to tackle the flower. Work on a smooth-surfaced paper which will allow white and pale tints to show up, and describe the overlapping petals by building up the tones in layers. Use a sharp pencil at all times to keep the work fresh and achieve the sharp edge quality. Experiment with blues and violet combinations for the greatest resonance in the background area.*

Conkers This close up shows off the exciting textures of the shiny conkers, their prickly cases and the veining of the leaves. Make the most of this in your work by burnishing compacted layers of reds, burnt sienna, and dark blue for the markings, and experiment with sgraffito or impressing for the leaf veins, using different implements for the various thickness of line.

Olives Notice the part the soft, out of focus background plays in this simple but powerful image, contrasting with the sharp clarity of the olives and a very subtle use of complementary color. Use just a handful of pencils to begin with: olive green, of course, plus a more yellow-green, burnt sienna, and a dark and light violet.

Butterfly *The strength of this photographic image is in the contrast between the small but vibrant color and patterning of the butterfly and the soft, dark, out of focus background. In order to accentuate this differentiation you could work on stretched white paper and mask out the image carefully with masking fluid until you have painted the background, or alternatively you could work on dark colored paper, keeping the image distinct with well-sharpened pencils.*

Seashells Shells are not easy to draw, as the spirals and the general asymmetry require close observation. Contour drawing is perhaps the best way to attempt this—describe the volume in terms of fine lines of differing weights, in two or three colors.

Animals

Kitten in close-up

For animal fur, blend by a combination of shading and light hatching. Use a plastic eraser in the direction of the fur to soften the blends and blur the edges. Shade the eyes densely, either reserving the highlights or lifting them out with an eraser.

Parrot *It could be helpful to enlarge this image, using a scanner or color photocopier so that you can see the structure of the feathers more clearly. Tackle these and the fine hairs of the frayed rope with sharp pencils and sgraffito methods.*

Horse race It is important to give a feeling of speed in your rendering, and you could do this by making vigorous hatched or shaded marks in the same direction as the horses' movement, from left to right. Carry this treatment through into the background, blending the marks to give a softer focus than that of the horses. Or you might like to work on the fine nuances of light and shade on the horse's coat, seen clearly in the close up, layering, compacting, and burnishing your color.

Carousel horses *Like the live horses, these painted and varnished creatures have a strong sheen, which can be achieved by careful blending and burnishing. Directional marks in the background will help to create the feeling of movement.*

Still life

Grapes *You will need to use strong tone and color contrasts to achieve this degree of vibrancy. The range of deep greens in the background will require several layers of densely shaded color—dark reds, purple, and indigo—to remove any vestige of white paper. Alternatively, a colored paper could be used as a base for the layering, followed by maximum use of the lighter pinks, oranges, and yellows for the fruit.*

Melon slices You could experiment with just red, yellow, and green pencils of various hues, with layering to obtain the intense shadows. Compacted layered color would be best to suggest the background, which acts as a foil to the clear pinks and oranges in the foreground.

African basket and gourd

This subject offers the artist lovely textures to play with. Use an eraser as a tool to soften the relatively light-toned basket work—the removal of pigment being an integral part of the gradual build-up of tone and color, as you define your work.

Baked goods

You could describe the woven patterns of the basket and the texture of the wheat, bread, and pastries using hatching and crosshatching techniques. Because of the relatively monochromatic color of the subject, vary the tones with obvious changes in pressure and density.

Buildings

Reflected buildings With an image as complex as this, you would need to trace the reflections in order to get everything in the right place. Start the color work by putting in the main blocks of color first and then overlay the shadows rather than coloring them separately. You may find an impressing tool with a fine point useful for the window grids of the office blocks.

Evening lights *Bright lights at twilight can make the sky seem a vivid blue, becoming deeper as the light fades. Make the most of the blue/orange complementary contrast to enhance the brightness by using dense shading or hatching for the lights and their reflections, or you could try using chalky oranges and yellows in light tones on a colored paper.*

Lighthouse at dusk *Play around with different sizes and scales when planning your compositions. Here, the horizon is very low, and the lighthouse fills the space vertically, its height accentuated by the perspective that leads the eye upward from almost ground level. You might try a colored paper for this subject, working the orange and yellow very densely.*

Onion domes *This image is all about rich color and pattern, which need to be crisp and clear cut. If the scale of your work is small, your impressing tool should come in handy, used both at the initial drawing stage when the white of the paper will be incorporated and possibly later as well, for the green and yellow patterns.*

Index

All materials and techniques are illustrated
Page numbers in *italics* refer to named drawings

Credits

Quarto would like to thank and acknowledge the following for supplying the illustrations and photographs reproduced in this book:

Laura Duis: **72**; Emin Kuliyev/Shutterstock: **164**; Lazar Mihai-Bogdan/Shutterstock: **165**; Juriah Mosin/Shutterstock: **166**; Vova Pomortzeff/Shutterstock: **167**; Elena Elisseeva/Shutterstock: **169**; Alexphoto/Shutterstock: **170**; Bude Moha/Shutterstock: **171**; Myrthe Krook/Shutterstock: **172**; Photooiasson/Shutterstock: **173**; Afaizal/Shutterstock: **174**; Vladimir Sazonov/Shutterstock: **175**; Frank Ungrad/Shutterstock: **175**; Ben Heys/Shutterstock: **176**; Tatiana Morozova/Shutterstock: **177**; Jacqueline Abromeit/Shutterstock: **178**; Ronald Sumners/Shutterstock: **179**; Orientaly/Shuttestock: **180**; Elke Dennis/Shutterstock: **181**; N Joy Neish/Shutterstock: **182**; Magdalena Kucova/Shutterstock: **183**; Donald R. Swartz/Shutterstock: **184**; Hannamariah/Shutterstock: **185**; Florida Stock/Shutterstock: **186**; posztos/Shutterstock: **187**

Quarto would also like to thank the following contributing artists who are acknowledged beside their work:

Elisabeth Aubury
Robin Borrett (www.artistandillustrator.co.uk)
Graham Brace (www.grahambrace.com)
Susan Brooks (www.susanbrooksfineart.com)
Angela Cater (www.geocities.com/angelacater)
Katriona Chapman (www.iris-illustration.co.uk)
Richard Childs (www.chumleysart.com)
Vera Curnow (Veracurnow.com)
Laura Duis (ldart@earthlink.net)
Kendra Bidwell Ferreira (www.kjfdesign.com)
Jeff George (www.jeffgeorgeart.com)
Malcom Harrison

John Hayes (http://motornstuffart.co.uk/index.htm)
Mark Hudson
Dyanne Locati
Richard Lovesey (www.loveseyfineart.com)
Robert Maddison
Richard McDaniel (www.richardmcdaniel.com)
K. Scott McGregor (www.scottmcgregor.co.uk)
Angela Morgan
Mike Pease (mrpease@comcast.net)
Steve Taylor
John Townend
Peter Woof (www.axisweb.org/artist/peterwoof)

All other illustrations and photographs are the copyright of Quarto Inc. While every effort has been made to credit contributors, Quarto would like to apologize should there have been any omissions or errors—and would be pleased to make the appropriate correction for future editions of the book.

With special thanks to Derwent for kindly supplying the colored pencils used and photographed in this book. For information on Derwent's products, visit: www.pencils.co.uk.